BEAUTIFUL IRELAND

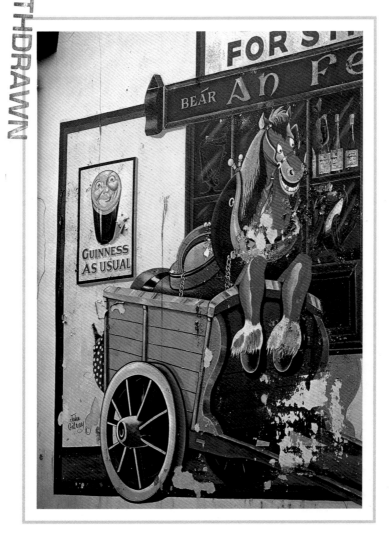

Gill & Macmillan

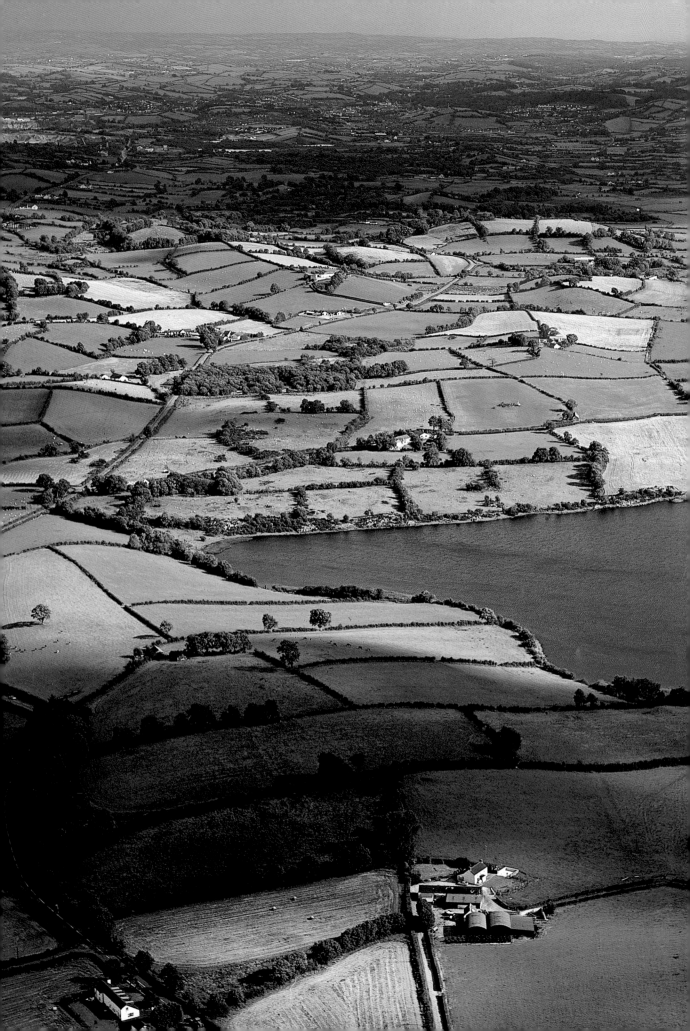

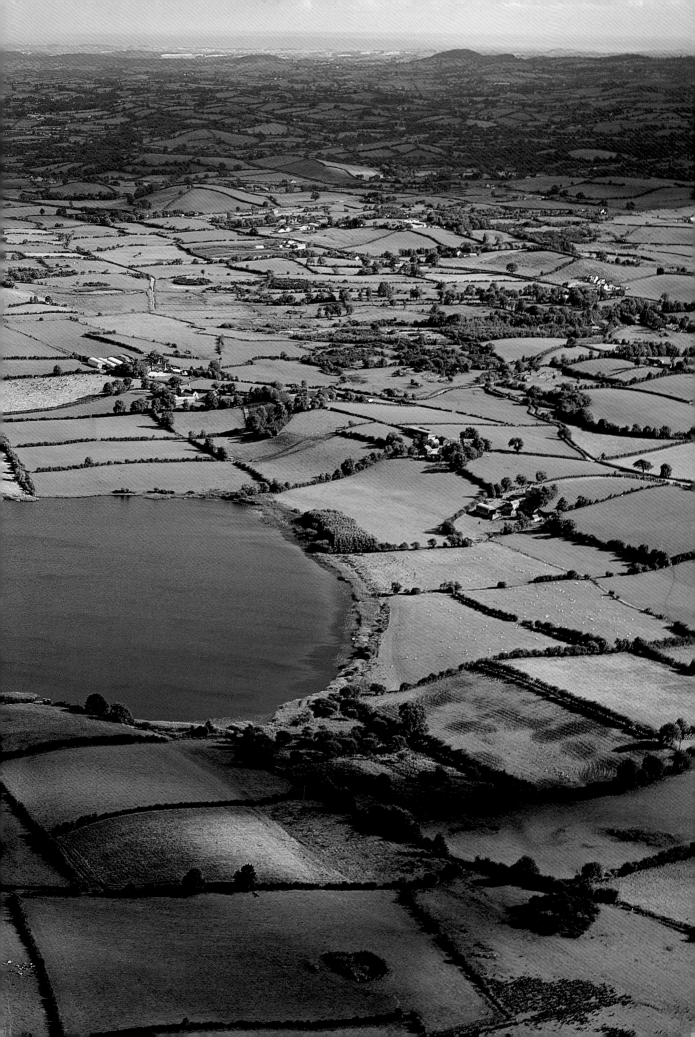

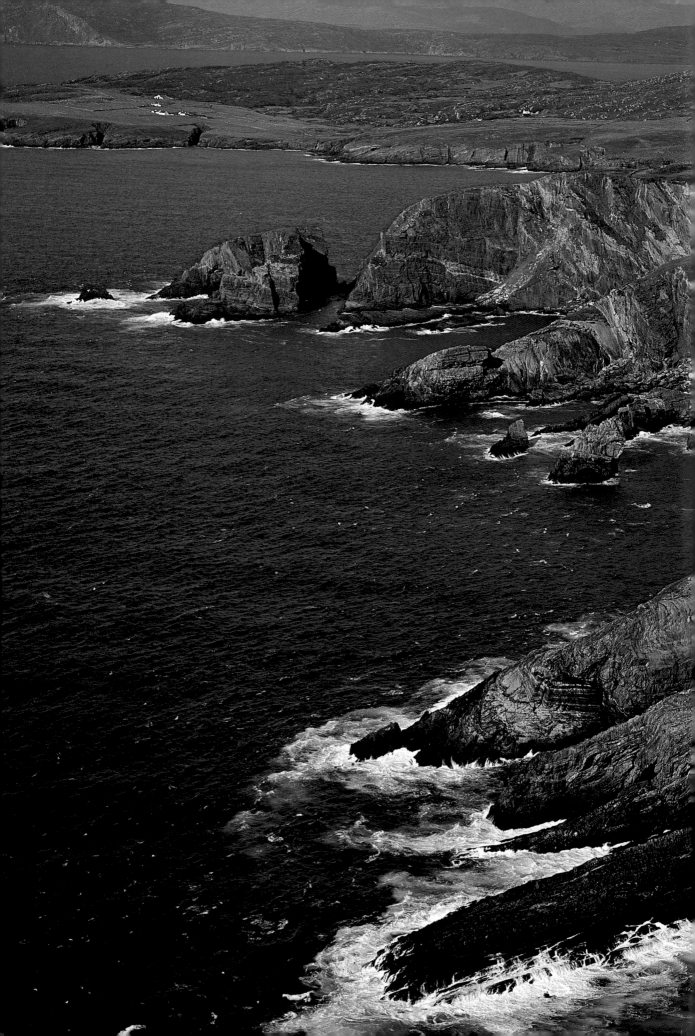

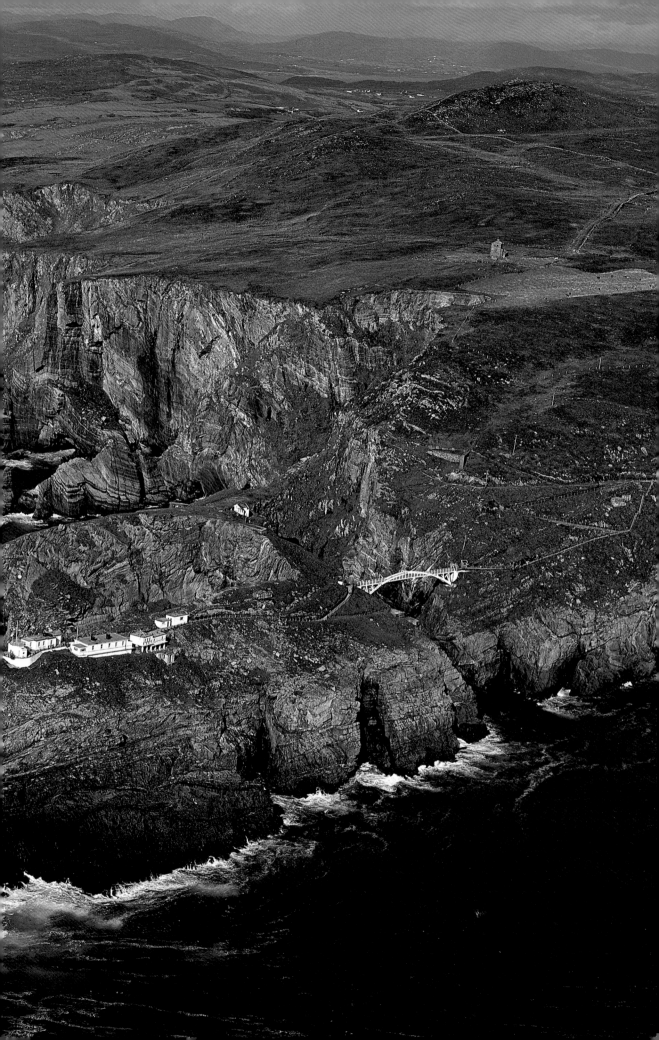

CONTENTS

TEXT
PETER SKINNER

GRAPHIC DESIGN
PAOLA PIACCO

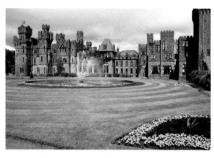

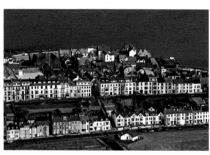

1 A cheerful pub mural suggests the state of a horse after a long night's drinking!

2-3 This view of Co. Down farmland reflects the brilliant greens of the Irish landscape.

4-5 Mizen Head, in West Cork, attracts the hardy hiker. Waves, cliffs, the coastguard station and bridge add to its appeal.

6 top left Ashford Castle, Co. Mayo, displays the Gothic Revival style in all its splendour.

6 top right The horse-drawn carriage, here in Killarney, Co. Kerry, is a way to enjoy the scenery.

6 bottom left Handsome family homes in Portrush, Co. Antrim. Note the traditional large church top left, and the single 'modern' house bottom left.

6 bottom right A Georgian farmhouse in Co. Tipperary.

6 right It's comforting to know for just how long much-loved Guinness has been good for the drinker!

7 Ireland is the land of winding rivers and broad estuaries. Here is Gweebarra River, Co. Donegal.

8-9 Atop its cliff, roofless Dunluce Castle radiates mystery and romance.

Published in Ireland by
Gill & Macmillan Ltd
Hume Avenue, Park West, Dublin 12
with associated companies throughout the world
www.gillmacmillan.ie

© 2004 White Star S.p.a., Vercelli, Italy

978-07171-3868-5

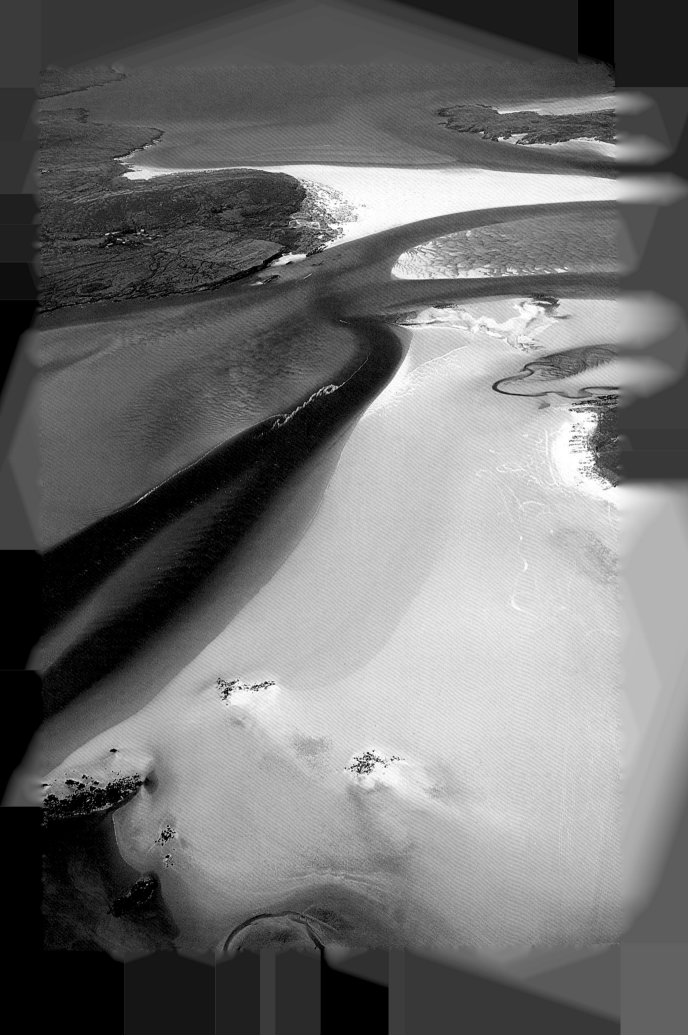

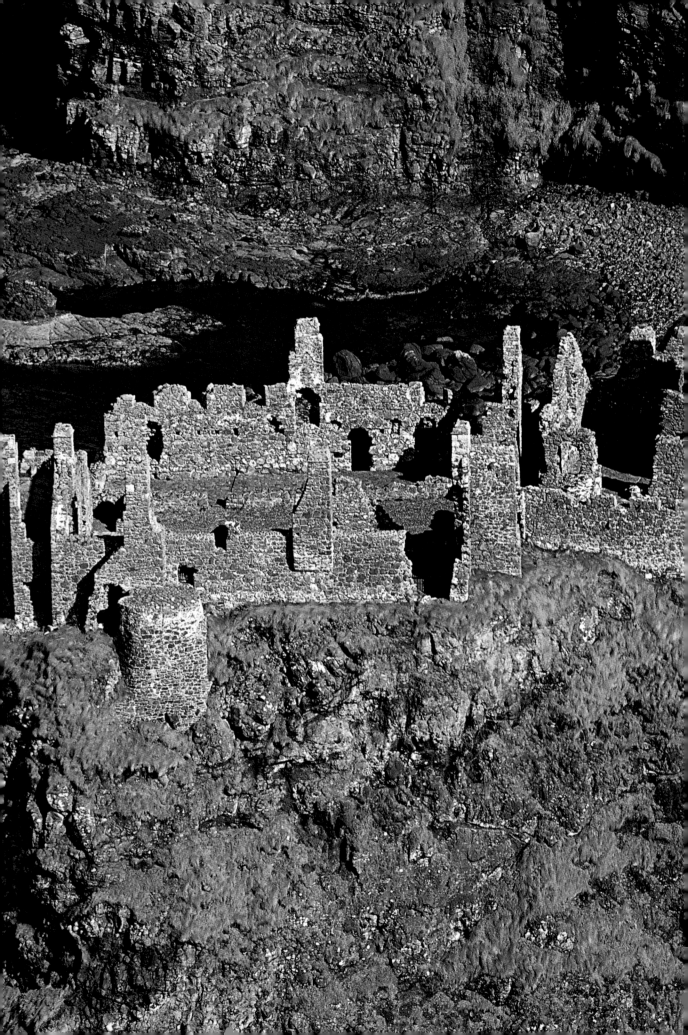

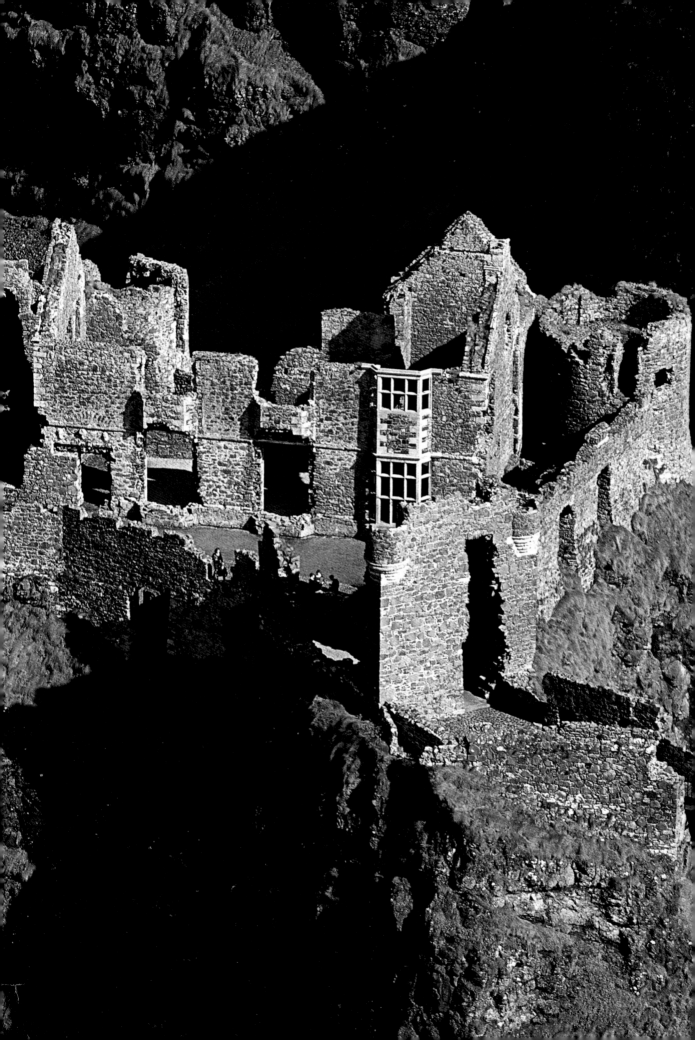

IRELAND, THE WELCOMING ISLE

Ireland! The ocean-washed land at Europe's farthest margin. The island is a paradox: formidable cliffs and rocky shores should guarantee safety from assault, yet vast estuaries and broad rivers expose the heartland to the invader. Irish chronicles record many a tragic blow, but courage and faith have kept the soul of the people inviolate. Don't think of Ireland wrapped in an imaginary Celtic twilight; don't assume that the Ireland of today, with its modern industries, its science and technology and its membership of the European Union, has relegated its rich history and culture to a tourist attraction. No: Ireland has created a thoughtful balance, maintaining a magnificent natural environment while sensitively meeting the needs of the 21st century.

The Irish have been great voyagers; many brought their energy and talents to Europe and the New World in times of both war and peace. Irish missionaries played a major role in spreading Christianity between the 2nd and 10th centuries, journeying throughout Europe, preaching, baptising and founding monasteries. In the 17th and 18th centuries, Ireland provided officers and men to the armies of Europe. The Irish played a major role in the peopling of North America, and in South America during the 19th century Irish generals led troops in wars fought by Spanish colonies for independence from Spain. Ireland's men of letters, from ancient bards through to Swift, Goldsmith, Wilde, Shaw, Yeats, Synge, Joyce and Beckett, have won world recognition as innovative talents.

10 left One of the most impressive aspects of County Antrim has got to be its famous coastline. The marine drive north from Larne, and then west to the resort of Portrush, follows 60 miles/96 km of one of the most beautiful coast of Ireland.

10 right A look at a traditional aspect of Irish country life, such as this horse-drawn cart driven by an elderly man, brings out the strong connection between the generations, past and present.

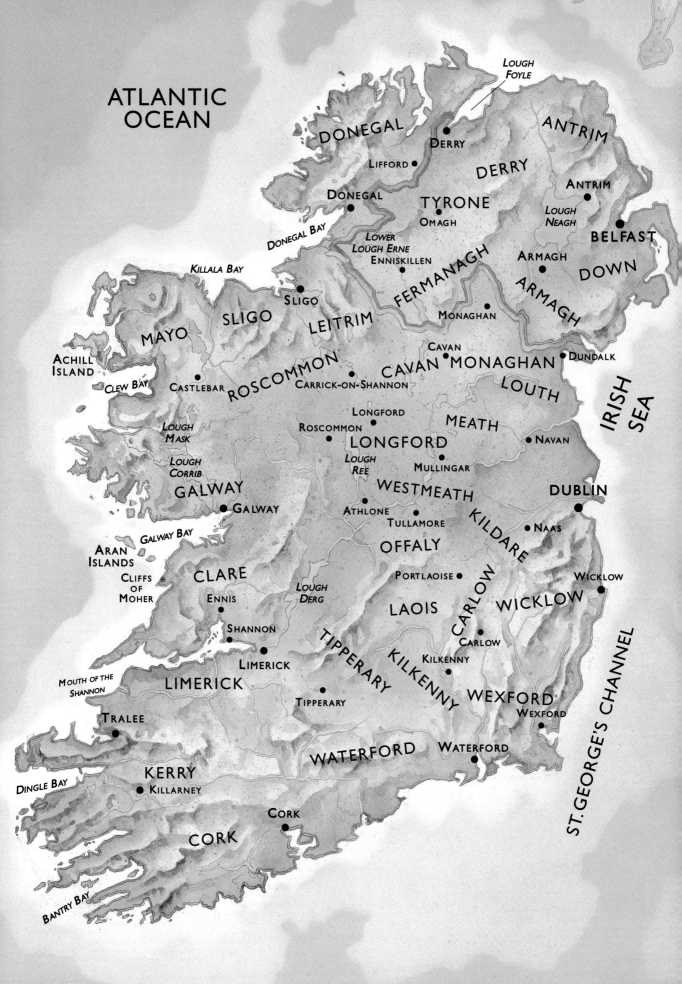

Few small countries offer the visitor as much as Ireland does. Its landscape changes constantly, offering a remarkable palette of colours.

There's the dominant green of field and woodland, well watered by frequent showers, and always the glint of water: sea, lake, river or stream. Then there are the darker hues of bracken-clad bog and turf (peat) cuttings and the silvery greys of limestone.

The traveller is never too far from a range of hills – however modest, the Irish are likely to call them 'mountains'!

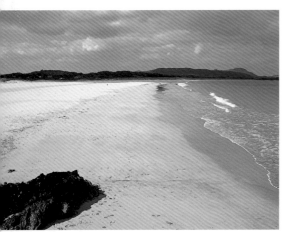

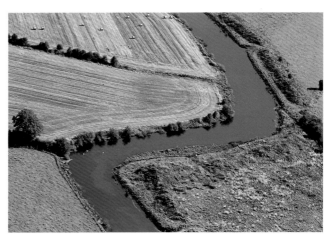

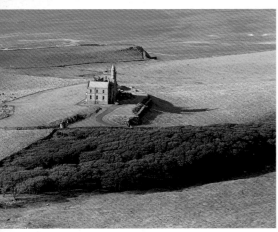

12 top The challenging golf course adjoining Lough Ree, Co. Westmeath, in the middle of Ireland. The area also offers hikes along nature trails.

12 centre left Portsalon Beach, deep in Lough Swilly, Co. Donegal, is sheltered from the Atlantic's boisterous waves and powerful tides.

12 centre right Well-watered Co. Offaly, with a western border on the River Shannon, is a productive mixed farming area, known for rich crop yields.

12 bottom left Classiebawn Castle in Co. Sligo, is a small castle with a traditional round watch tower that harks back to troubled times.

12 bottom right Trees and water add to the challenges facing the golfer at the beautiful Cahir Golf Club course, Co. Tipperary.

13 Dunmanus Bay, West Cork, perfectly typifies the headlands and inlets of Ireland's rugged and beautiful southwest coast

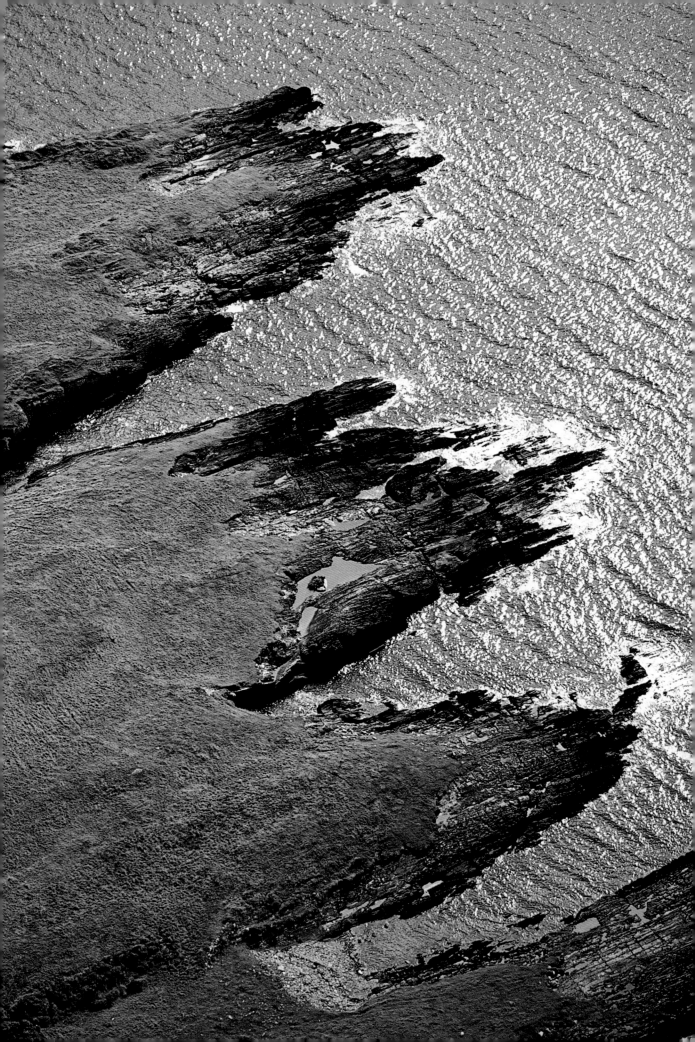

Variety of architecture is one of Ireland's greatest attractions for the visitor. Whether the simple vernacular of cottage, farm and church, or the quiet dignity of Georgian terraces and squares, or the numerous country houses, often whimsical in their architectural vagaries, there are buildings to delight every taste.

Old towns have made discreet marriages with modernity; fine architecture is carefully preserved. Art, theatre and music are proudly cherished.

There's excellent shopping, with both traditional wares – glass, linen, tweeds, handcrafted jewellery, and modern goods – high fashion, top-of-the-line electronics, books, CDs and tapes.

Today, Ireland welcomes visitors from the world over, and no one can claim to know life in all its fullness without a visit to this magical place.

We hope that *Beautiful Ireland* will serve as an introduction to the country.

It offers a circular tour of landscape and towns, a rapid passage through Ireland's heartland, and a sampling of Ireland's culture, folklore and sports. May it be an invitation to visit us – and to experience a traditionally warm Irish welcome!

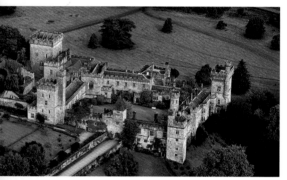

14 top The end wall of the now roofless north transept of the cathedral rising above the Rock of Cashel, where Cromwell laid siege in 1647.

14 bottom left Imposing Ashford Castle (Lough Corrib, Co. Mayo), part 13th century but largely Gothic Revival, is now a luxury hotel.

14 bottom right Ancient Celtic crosses reflect the power of the faith at the Rock of Cashel, Co. Tipperary, once a place of kingly power.

14-15 Cobh is known for its Georgian and Regency waterfront houses, with their pastel-tinted façades, and also for its huge harbour.

15 top left Co. Waterford, on Ireland's southern coast, is an area of tranquil landscapes, attractive rivers and rich farmlands.

15 top right These two-section cottage doors in Ennistymon, Co. Clare, colourfully capture a fast disappearing way of life.

16-17 Cobh harbour combines handsome waterfront houses with the powerful lines and soaring steeple of close-by St Colman's Cathedral.

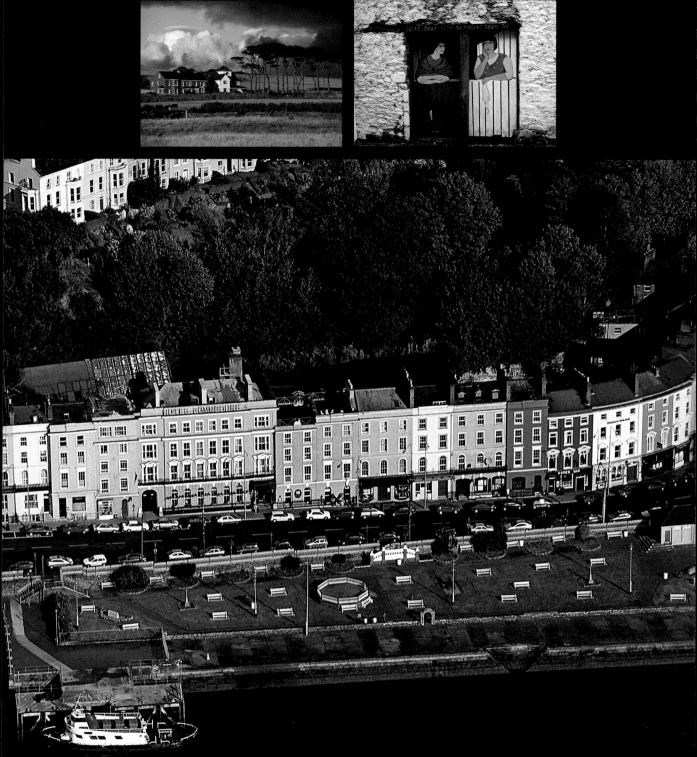

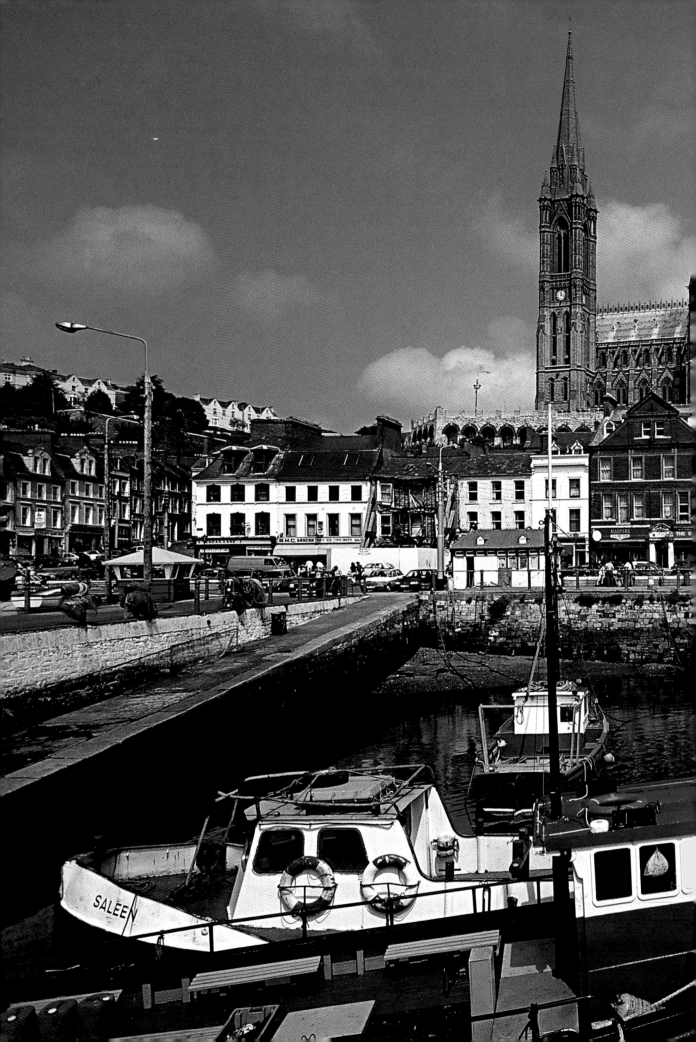

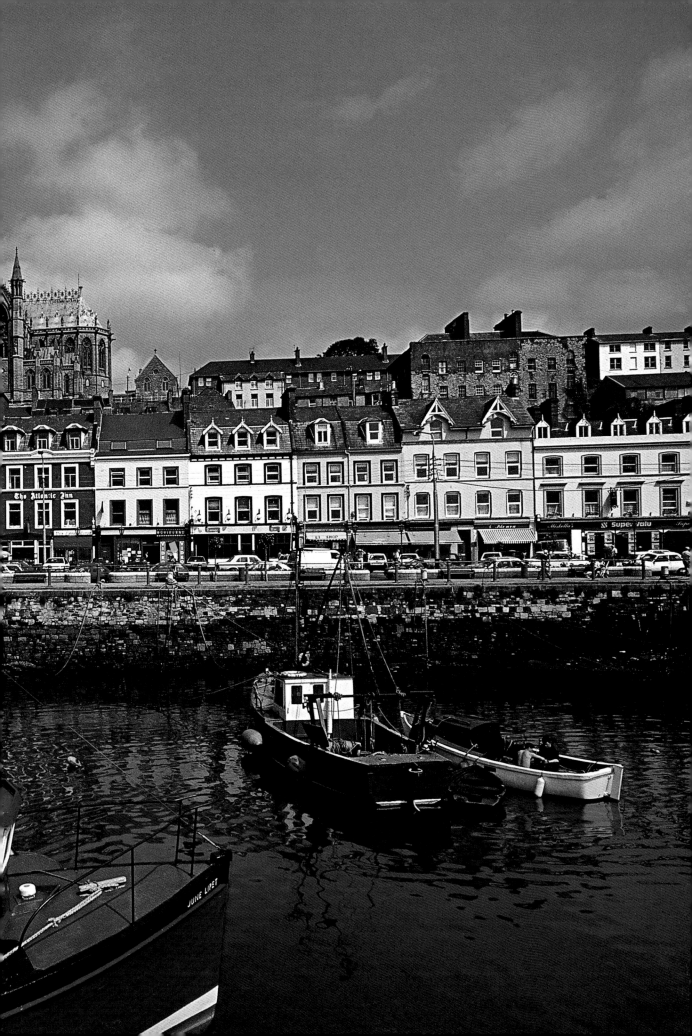

LANDSCAPE AND NATURE

It's hard to imagine a greater variety of scenery than Ireland offers. Mountains both verdant and desolate, leafy glens, gentle bogland, tumbling streams, slow-flowing rivers, majestic cliffs, sandy beaches, hidden coves, and a profusion of wildlife and flowers – Ireland has it all. In Ireland it is impossible to be more than 70 miles/112 km from the sea (and Ireland has 3,500 miles/5,630 km of coastline), which accounts in part for the country's temperate, moist climate and celebrated greenness. Moreover, it is surprisingly easy to explore. The whole island (circa 32,524 sq miles/84,205 sq km) is only about two-thirds the size of New York State, and its compact shape makes a clockwise circuit – broken by detours to the interior – ideal for visitors keen to see as much as possible. The Cooley Peninsula, marking the Republic's border with Northern Ireland, is an ideal starting point for exploring the island's southeastern quadrant, the region historically known as Leinster. It is generally marked by

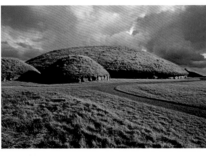

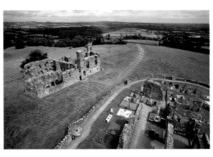

rolling or hilly land towards the coast and a flatter, wetter, more clayey terrain inland. The peninsula, bounded to the north by Carlingford Lough and to the south by Dundalk Bay, offers cliffs, rocky headlands and also sandy beaches, besides the Cooley Mountains that form its spine. To the south is the winding River Boyne; here in 1690, William of Orange, Britain's invited Protestant ruler, defeated and ousted James II and the Catholic cause.

Inland and just north of the Boyne, in the rolling farmlands of County Meath, stands the huge 20-feet/6-metre high shallow turf-topped dome of Newgrange burial chamber. This Neolithic passage grave, dating back to circa 3200 B.C., was restored over a decade during the late 1960s–early 1970s, and its impressive white stonework facing dominates the quiet landscape. A number of stones slabs bear the incised spiral patterns found at many Neolithic sites, and (of great interest to paleo-astronomers), on December 21st, the day of the winter solstice, the rising sun's rays shine directly into the burial chamber at the centre of the tomb. Close by are the equally impressive Knowth and Dowth tombs. A few miles west of the tombs is Beauparc, where the fertile Boyne valley is particularly attractive. Leaving the Boyne at Navan, visitors can strike southeast and 5 miles/8 km or so brings them to the Hill of Tara, the traditional seat of Ireland's High Kings until the death of Malachi II in 1022. Today, this ancient seat of royalty and governance presents grass and the circular ditches and mounds of some Iron-Age forts, dominated by a statue of St Patrick. In the centre of one stands the 'stone of destiny', significant in the kingship of early Ireland and in the patriotic emotions that Tara engenders. Due south, the placid Royal Canal, connecting Dublin to the River Shannon and the western province of Connacht, will reward wildlife enthusiasts; the waterway has become a protected wildlife and scenic area, offering recreation and cruising.

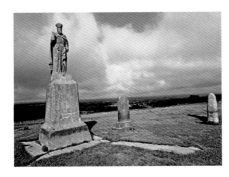

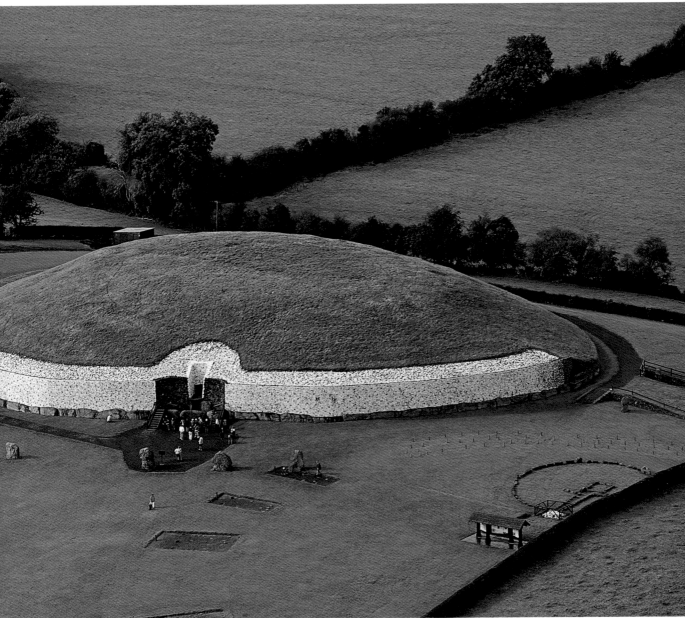

18 top The Knowth passage graves, Co. Meath, share the architectural features of nearby Newgrange, but are even richer archaeologically.

18 bottom The impressive remains of medieval buildings on the Hill of Slane, Co. Meath, where St Patrick celebrated Easter in 433.

18-19 Sensitive rehabilitation has restored Newgrange Passage Grave (one of many in Ireland) to its original monumental dignity.

19 top left Sombre grave markers on the Hill of Tara harken back to the lost glory of ancient Ireland.

19 top right The church and graveyard at the Hill of Tara, Co. Meath, ancient seat of the High Kings of Ireland. Christianity and invasions led to its decline.

To the southeast is one of Ireland's loveliest landscapes, the rounded contours of the wild Wicklow Mountains with their magnificent lakes and valleys. In the early 1800s the British army built the Military Road that runs through the mountains, in an attempt to control native rebellion.

It stretches to Laragh which is now a starting point for numerous local tours that bring visitors to such historic sites as the upland Sally Gap with its bogs and pools,

Below the Wicklow Mountains the terrain becomes gentler, bounded to the east by the Irish Sea and to the south by the Atlantic Ocean.

Well watered by the picturesque River Slaney, the central plain is fertile farming land, sheltered in the west by the Blackstairs Mountains.

Close to Ferrycarrig just outside Wexford town is the fascinating Irish National Heritage Park with its skilful recreations of

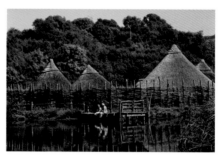

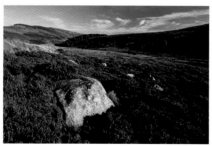

Powerscourt House in Enniskerry with its world-class gardens, and Glendalough with its lakeside monastic ruins and slender round tower, framed by majestic mountains. The region has seen a resurgence of traditional crafts, including handweaving in Avoca.

tombs, shrines, homesteads and artifacts showing how Irish life was lived down through the centuries. Another view of history is offered at the Irish Agricultural Museum in Johnstown, which demonstrates later life on the land and also depicts the horrors of the Great Famine of 1845–48.

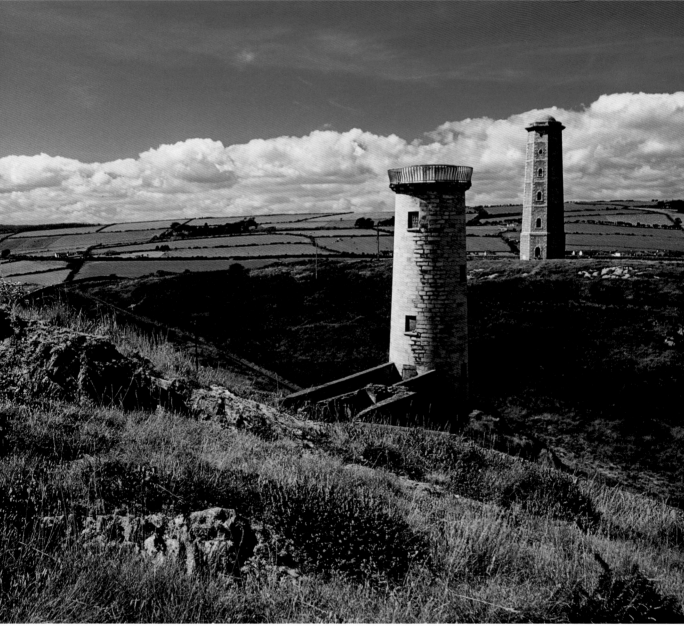

20 top Glendalough monastic site, with its fine round tower, Co. Wicklow. Though the Vikings sacked the monastery, the lakes and woods remain a haven.

20 centre left Their shallow draught enabled longboats to penetrate Ireland's rivers. This replica is at the National Heritage Park, Ferrycarrig, Co. Wexford.

20 centre right A settlement of reconstructed prehistoric 'crannogs' at the National Heritage Park, Ferrycarrig, Co. Wexford.

20 bottom left Sally Gap in the Wicklow Mountains presents a typical upland scene of rock, bogs, heather and bracken.

20 bottom right Powerscourt House (built in the 1730s) has gardens completed in the 1870s, now famous for their varied layouts and magnificent plantings.

20-21 Wicklow Head's two disused lighthouses once warned shipping in the Irish Sea. Today the newer octagonal tower is available to rent.

22 top Dungarvan Bay, Waterford, where a spit of land and beaches separate the harbour from the sea to the southeast.

22 centre top Lying west of the Rock of Cashel, is the Cistercian Hore Abbey, founded in 1266.

22 centre bottom Ancient Celtic crosses stand out dramatically, surveying the panorama from the Rock of Cashel, Co. Tipperary.

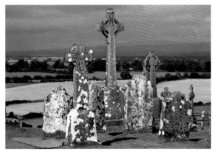

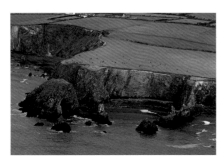

22 bottom The Co. Waterford coastline is often marked by cliffs and rock formations.

22-23 The Rock of Cashel, Co. Tipperary. Centre, the cathedral's south transept's three lancet windows; right, in lighter stone, Cormac's Chapel. Foreground left and right; the Hall of the Vicars Choral and the Dormitory.

23 bottom Both beaches and cliffs characterise the Co. Waterford coast. Here sand and sea provide easy recreation.

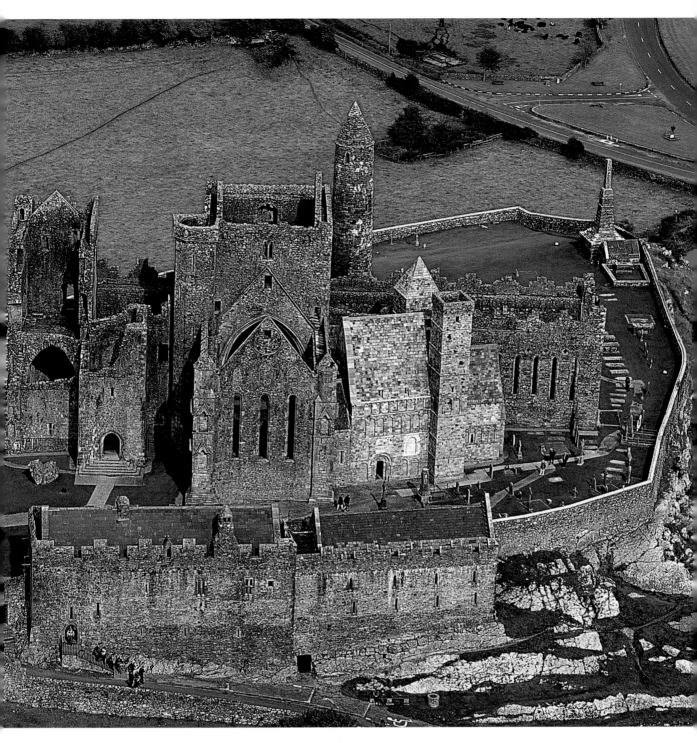

On the southeast coast, the area around Waterford, straddling the boundary between Leinster and Munster, Ireland's southwestern quadrant, offers delightful scenery. Just north in County Tipperary is the Rock of Cashel, with its High Cross and Chapel (12th century), its Gothic cathedral (13th century) and fine 15th-century castle. County Waterford rolls out from the Comeragh and Knockmealdown Mountains to a coastline that offers fine bays, beaches and coves. Both the Suir and the Blackwater rivers are delightfully scenic, and the latter is an angler's paradise.

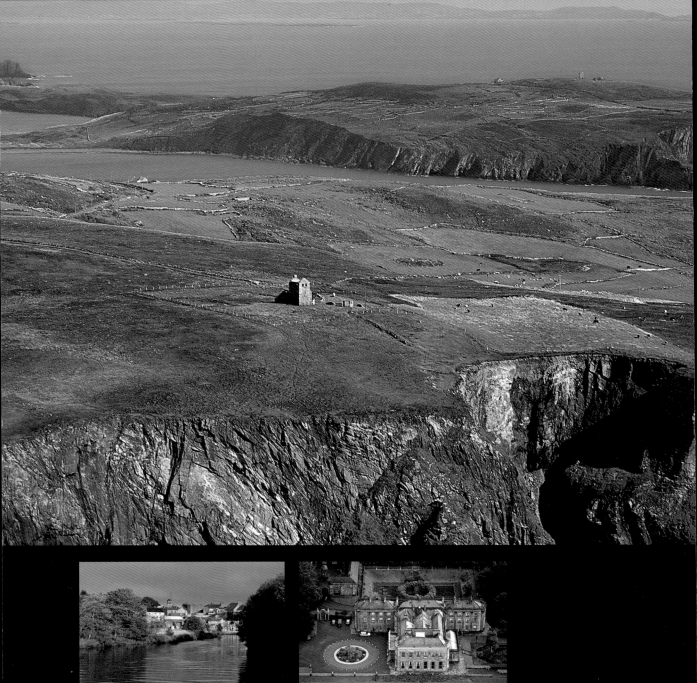

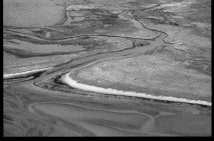

Many visitors fall under the spell of Munster's natural glories, particularly in rugged West Cork and Kerry, with their magnificent range of rocky peninsulas thrusting into the Atlantic, sheltering fishing villages and unspoiled upland countryside.

The Blackwater and Lee valleys, Bantry Bay and Glengarriff, Kenmare river and Dingle Bay and Peninsula all reflect nature at her finest: benign and stormy by the seasons. Walking, hiking, sailing, golfing and fishing are superb, and unspoiled traditional life is on offer in small towns and quiet villages. The Lakes of Killarney, flanked by farmland to the south and the impressive Purple Mountain, are paradise in miniature, much of the area thankfully protected as a national park with well-maintained trails. Leaving the Lakes to the Ring of Kerry provides a wonderful route of incomparable vistas; it circles through the villages, hills and valleys of the rugged Iveragh Peninsula. There's an edge-of-the-world quality to the coastline: beyond the rocky Skellig Islands the often stormy Atlantic swells unbroken to North America. Great Skellig boasts a unique treasure: a small, utterly isolated and long-since abandoned 6th-century monastery. Don't miss the dramatic MacGillicuddy's Reeks, Ireland's highest range.

Inland Munster presents gentler, flatter terrain, cut by valleys of the Maigue and other small rivers.

The landscape presents a slow-paced scene of mixed farming, with small market towns and villages.

24 top Dunmanus Bay, West Cork, runs between finger-like, cliff-skirted peninsulas. The land is mainly used for grazing sheep.

24 centre left Skibbereen, a flourishing crafts town on the Co. Cork coast, was one of many communities devastated by the Great Famine of the 1840-50s.

24 centre right This mansion on Bantry Bay, Co. Cork has an impressive garden front and looks onto manicured lawns and terraces.

24 bottom left Cobh Harbour, Co. Cork. The huge sheltered harbour's inner shores are clearly a choice location for gracious living.

24 bottom right Youghal Bay, Co. Cork, into which the River Bride flows. The estuarine wetlands are rich in marine and bird life.

25 This handsome but unadorned Victorian-era church in Skibbereen boasts well-tended lawns and flowerbeds.

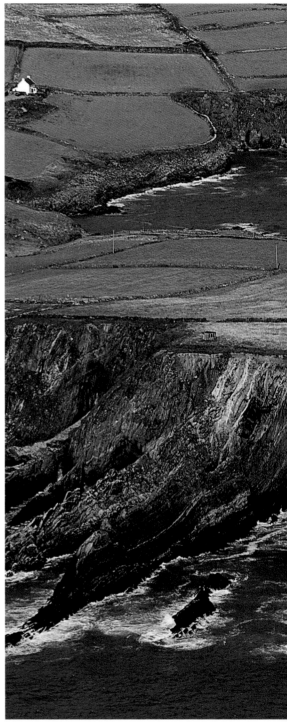

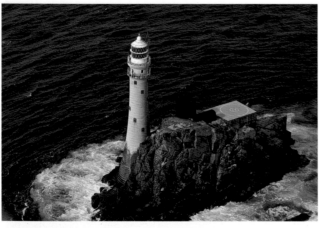

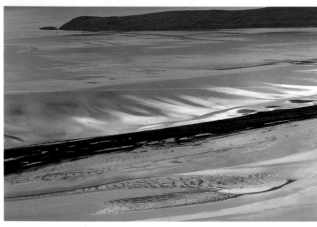

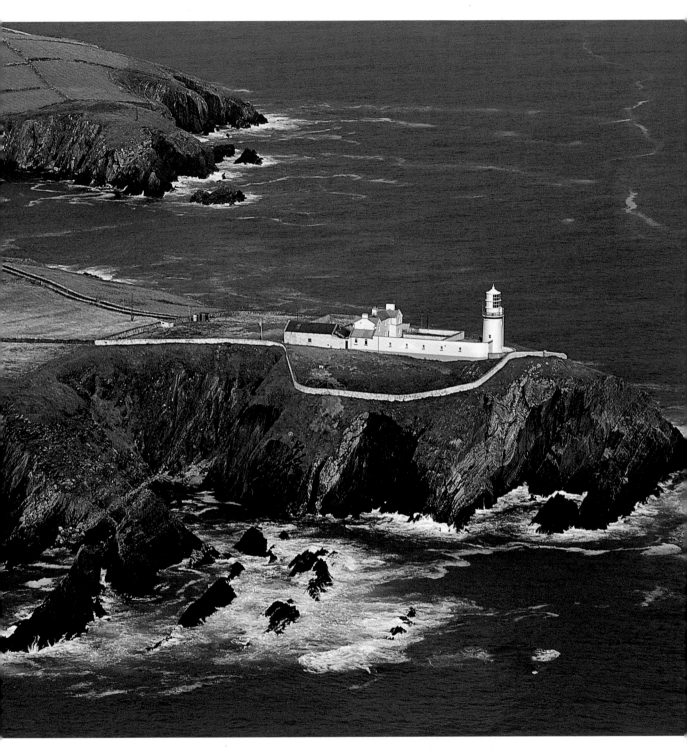

26 top Kinsale Harbour is a mecca for sailing enthusiasts and Kinsale village, considered one of Ireland's prettiest, is a perfect on-shore base.

26 centre top The shore, a whitewashed farmhouse and a castle of honey-coloured stone provide a pleasing contrast near Castletownshend, Co. Cork.

26 centre bottom The Fastnet Rock rises sheer from the Atlantic south of Roaringwater Bay, Co. Cork. Legendary winter storms batter the lonely lighthouse.

26 bottom Youghal Bay, Co. Cork. While here a study in tranquility, the Bay is no stranger to winter storms.

26-27 Galley Head lighthouse on Co. Cork's southern coast offers more by way of views than do neighbourhood pubs and human company.

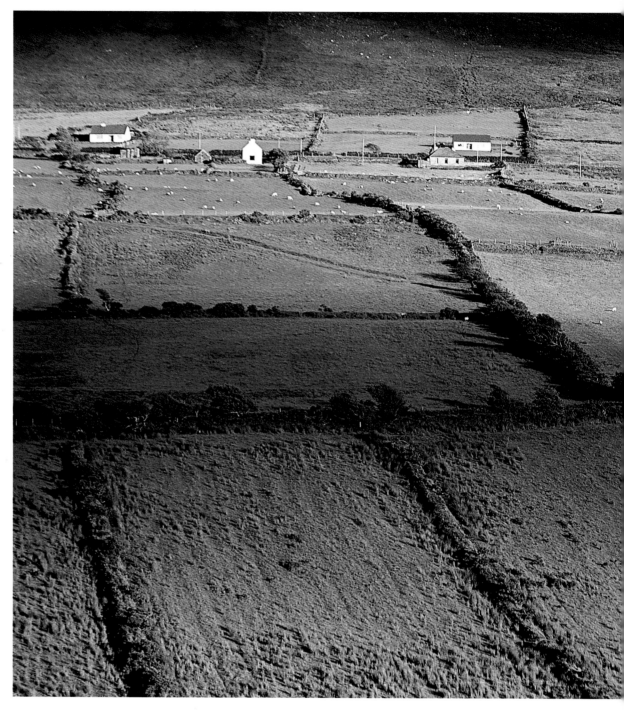

28-29 *More grazing land, fewer crop fields and smaller cottages hint at a tougher life in Co. Kerry than along Ireland's southern coast.*

29 top *In addition to being a holiday centre, Tralee Bay, Co. Kerry, is a region of rich farmland, offering tranquil vistas of sea and sky.*

29 centre *A fertile valley in a gentle Co. Kerry landscape. Hills ('mountains' to the locals) offer protection against the winds.*

29 bottom *The Magharee Islands off Castlegregory peninsula, Co. Kerry, showing an ancient enclosure with now ruined structures. Hedges have given way to stone walls in this region.*

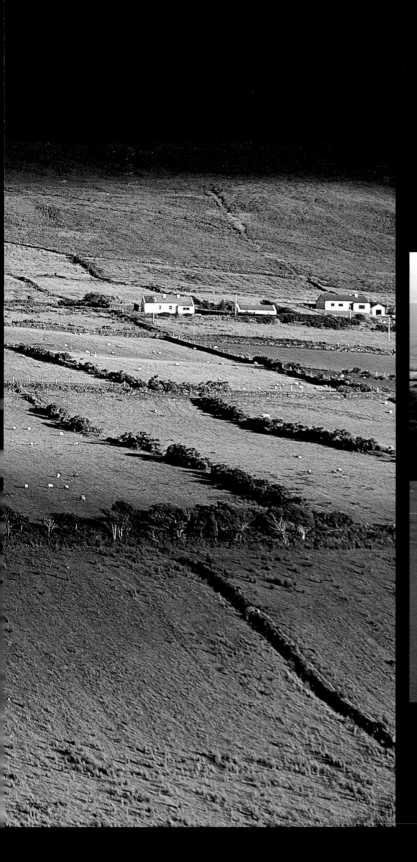

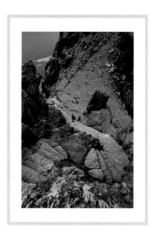

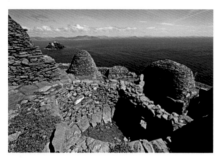

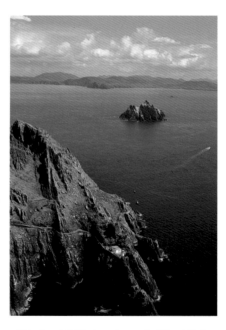

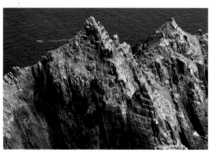

*30 top The stone stairway the monks built on Great
Skellig more than a millennium ago ascends over
700 ft/213 m to their cells and oratories.*

*30 centre left The dry-stone monastic cells on Great
Skellig have defied wind and rain for well over 1,000
years, a testament to the skill of their monk-builders.*

*30 bottom left The jagged summit of Great Skellig.
Fortunately, given their work and prayer, the monks
did not dream of laying out gardens and lawns.*

*30 right The Great Skellig lighthouse – as isolated as
the long-abandoned monastery and sharing the same
unbounded views.*

*31 Inhabited by hardy monks from the 6th to 12th
century, rugged Great Skellig is now home to a
lighthouse, high above the tumultuous seas.*

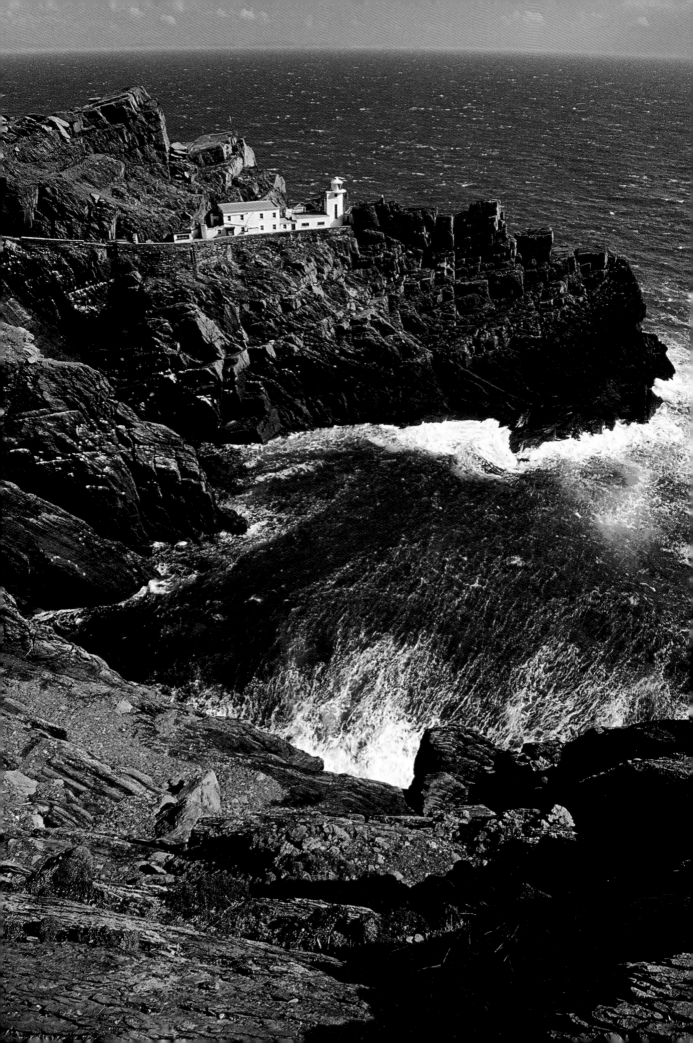

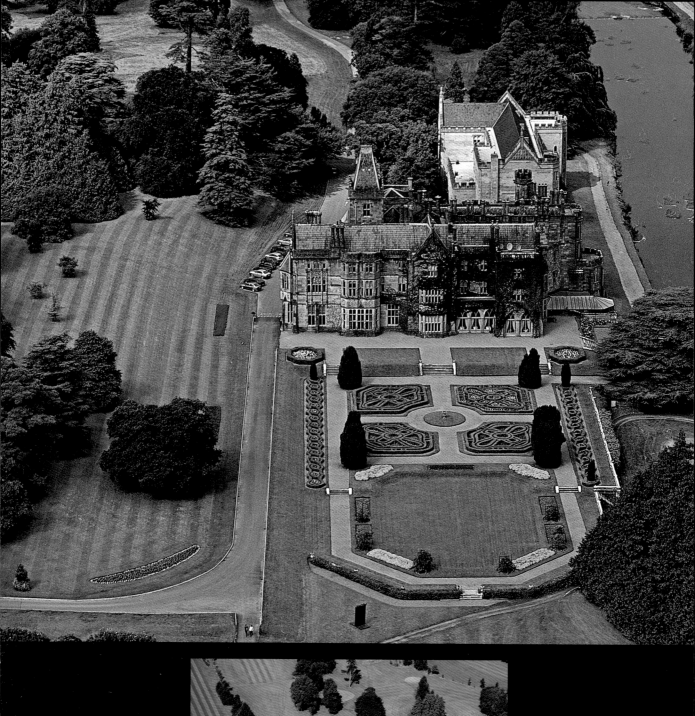

North to County Limerick, the rich farmland has earned the name 'The Golden Vale'; it offers many scenic trekking trails. The dominant feature is the broad 60-mile/96-km long Shannon estuary.

The river, larger than any other in Ireland or Great Britain, is no longer a primary shipping route; it has been restored up to its headwaters in Lough Allen, and, via the 500-mile/805 km Shannon-Erne Waterway, connects to Upper Lough Erne. The river and its environs are maintained for boating, fishing and camping, with great opportunities for wildlife and birdlife observation.

From headwaters to estuary, the Shannon is a primary breeding area for geese, swans, herons and other birds. Today rare species are protected and bird sanctuaries abound.

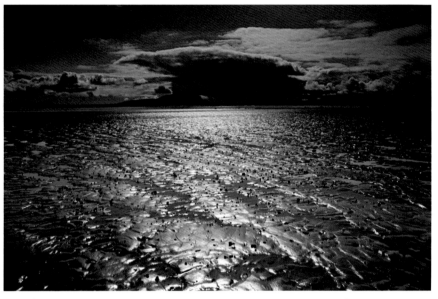

32-33 Adare Manor, built in exuberant Victorian Gothic style and now a hotel, is close to Adare village, sensitively restored in the 1820s.

32 bottom The ruins of the Franciscan Friary, an abbey founded by Thomas Fitzgerald in 1464, stand out in the area of the golf course of Adare Manor.

33 top The silvery Shannon debouches into its great estuary between Cos. Clare and Limerick. Low tide reveals vast areas of glistening mud and sand.

33 bottom left Askeaton, a riverside town with a castle, is in Co. Limerick. To its south is Castle Matrix; to the north, the Shannon estuary.

33 bottom right A typical scene in rural Co. Limerick: a farmer, his horse and cottage; behind, one of Ireland's many ruined churches.

34 top left A lonely lighthouse in the broad River Shannon, once a busy shipping route, but now more given to recreational boating and sailing.

34 top right People having a walk around O'Brien's Tower above the Cliffs of Moher in Co. Clare.

34 bottom left This view of farmland adjoining the Shannon (broadening here into Lough Derg), depicts the typical plain of central Ireland.

34 bottom right The Burren ('rocky terrain' in Gaelic), Co. Clare, is an area of fissured, fast-draining limestone, home to many uncommon plant species.

35 At their highest, the sheer, striated Cliffs of Moher in Co. Clare tower over 700 feet/213 metres above the Atlantic Ocean.

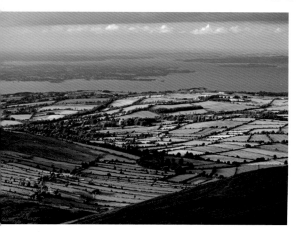
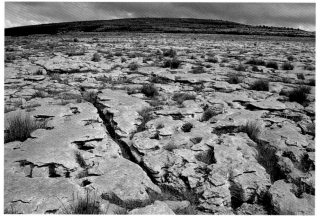

North and west of the Shannon lies County Clare, with its wide variety of landscapes and an unrivalled natural wonder. The breathtaking Cliffs of Moher, its rock layers striated with thinner bands of darker shale, rise sheer almost 700 feet/213 metres, a massive rampart against the Atlantic Ocean which can swell in awesome winter storms. There is a visitors' centre and short or longer walks can be made along the 5 miles/8 km of cliffs.

Not to be missed is the curious O'Brien's Tower (a miniature 'castle') built in 1835 to enable visitors to enjoy the cliff-top vista and bird watching; guillemots, razorbills and other seabirds nest on the cliff ledges.

Follow the coast northeast from the cliffs; south of Galway Bay is the moonscape area of the Burren, a region of generally flat, fissured limestone. Rain disappears instantly through the fissures (grykes) and over the centuries has carved out underground networks of channels and caves. Where there is soil cover, turloughs (shallow lakes) fill with winter rain. The Burren is known for a rich fauna and flora, including the alpine cranesbill and mountain aven, both unique in Ireland to this region.

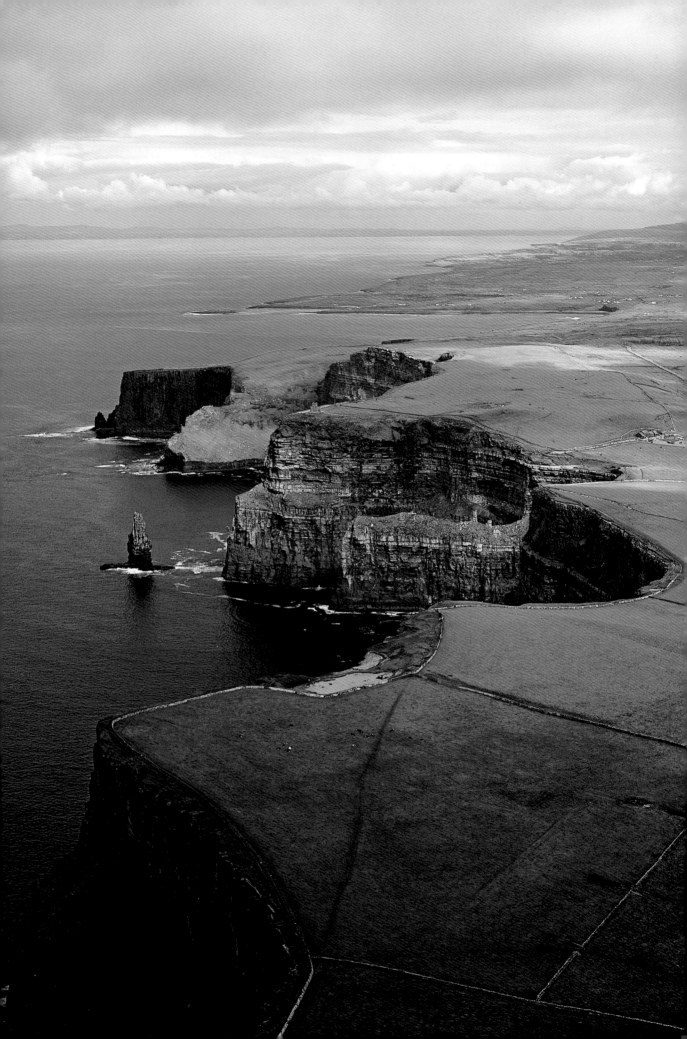

Those seeking a sense of a remote, un-changed Ireland should make the boat trip to the Aran Islands, where the harsh lime-stone terrain is home to the hardy islanders who fish, farm and receive tourists.

Traditional boats of canvas-covered wooden keels and ribs (currachs) are still in use; some older women still wear the tradi-tional red-flannel skirt while their menfolk sport hand-woven tweed jackets. For the archaeologist, there are Iron-Age forts to visit.

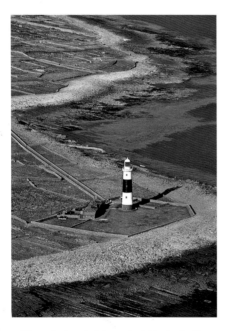

36 top Inisheer Lighthouse, Aran Islands, Co. Clare. Typically the lighthouse plot is walled and cultivated.

36 bottom Inisheer Lighthouse from inland. The island's small, irregular and carefully walled fields are seen here to advantage.

36-37 Tiny fields with dry-stone walls on Inisheer, one of the Aran Islands, Co. Clare, reflect endlessly subdivided land. The islands are a stronghold of tradition.

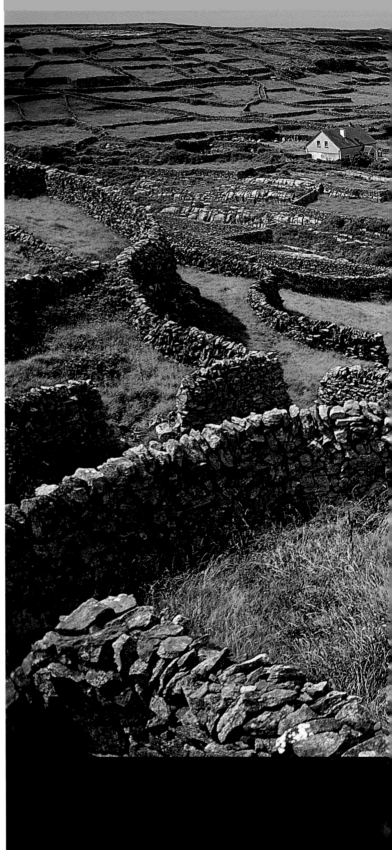

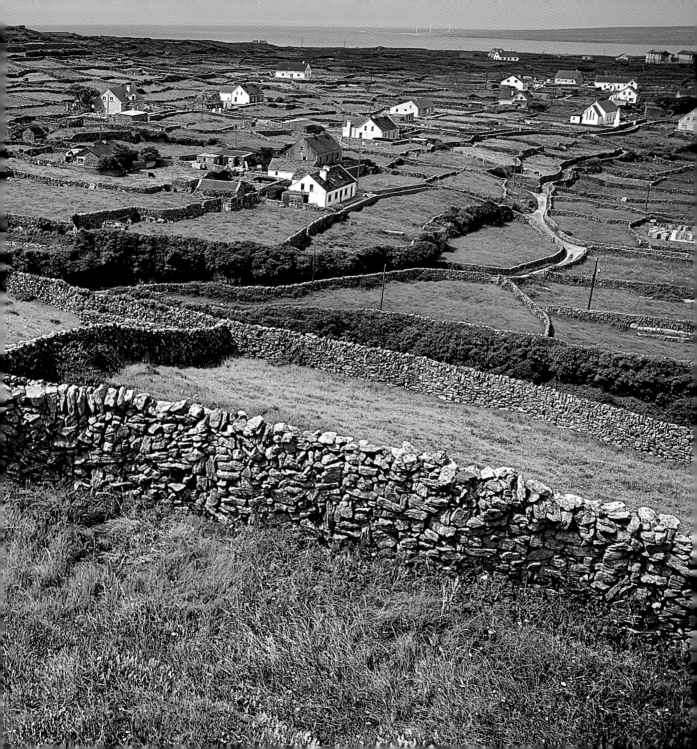

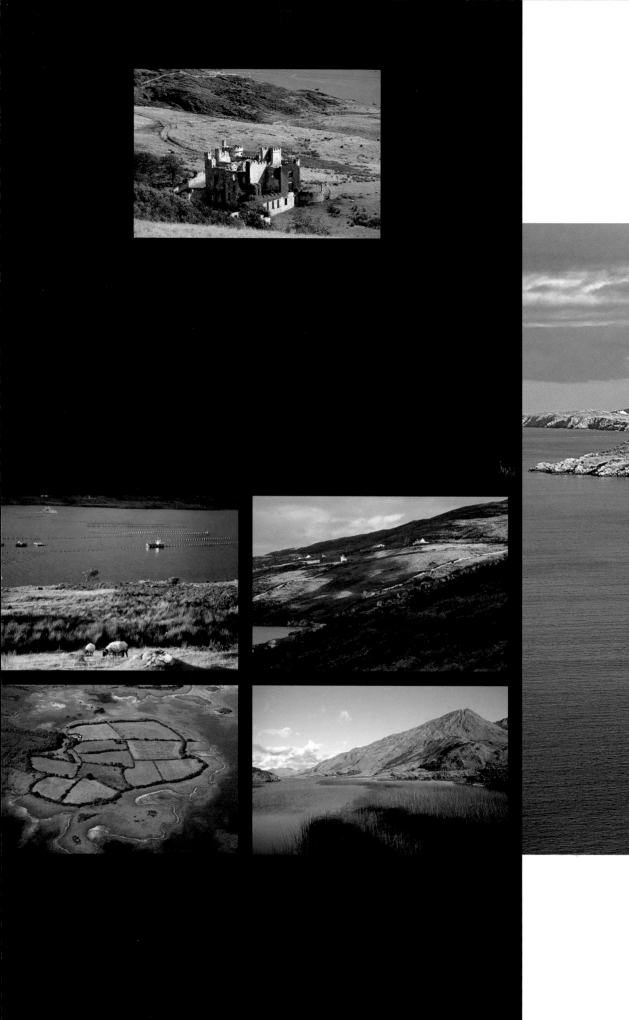

38 top Clifden Castle, Co. Galway, is one of the many 'why-not-restore-it' romantic ruins that dot the Irish countryside.

38 centre left Kilkieran's extensive harbour, in the bay of the same name, provides welcome shelter from Atlantic storms.

38 centre right Clifden Bay, Co. Galway, lies in the lee of the Twelve Bens. The 'model town' of Clifden, founded in 1812, is now a crafts and visitors centre.

38 bottom left Co. Galway's coast sports a patchwork quilt of green islands and quiet waterways that invite exploration.

38 bottom right Lough Kylemore, Connemara, Co. Galway, a place of fabled tranquility that has drawn tycoons, nuns and visitors to its shores.

38-39 Known for its rugged and often near-deserted beauty, the Co. Galway coast is generally less gentle than Ireland's sunny southern coast.

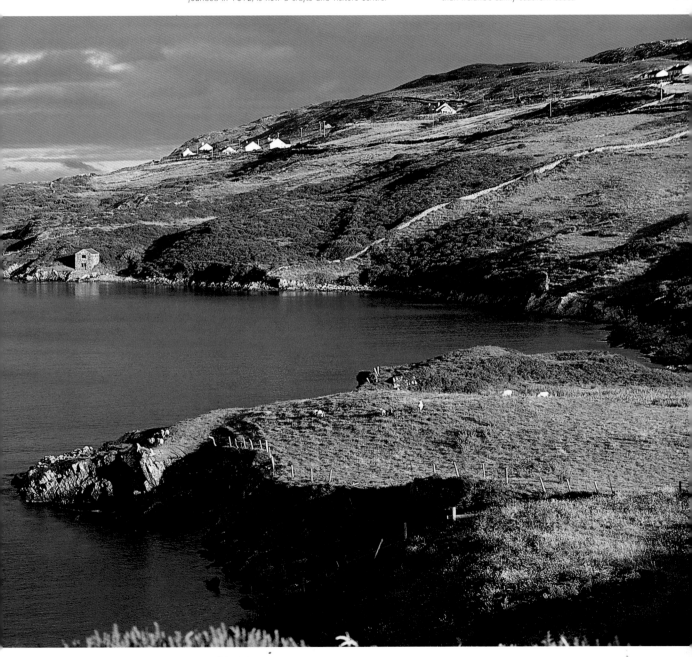

North of County Clare the rugged province of Connacht begins with County Galway, bordered to the southeast by Lough Derg (a broadening of the Shannon), extending north and west over rich farmland to the huge Lough Corrib, which divides off a mountainous northwestern region with the stark Maumturk Mountains to the north, and the silent, unspoiled expanse of Connemara National Park to the west, with its heather, bracken, wetlands and bog.

Here, magnificent mountain scenery, with the familiar Twelve Bens and stark headlands and cliffs, delight the visitor. It's a remote, challenging region, one of unpredictably stormy weather and relatively few convenient roads to warmth and comfort. The area is within a Gaeltacht, a region in which the Irish language, Gaelic, is still spoken and where the tradition of a slow-paced, self-sufficient lifestyle is proudly maintained.

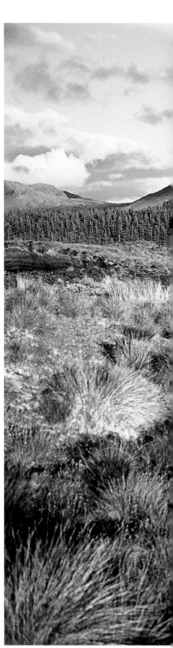

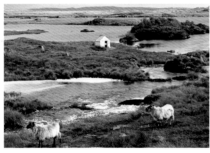

40 top left A typical Connemara landscape. Where bogs give way to grassland, hardy sheep graze unattended.

40 top right Connemara, Co. Galway, is known for its tough, stocky ponies, still ridden by locals and visitors and used to pull farm carts.

40 bottom left Rounding up the flock is always a challenge in Connemara, where sheep find their way to every uncropped patch of grass.

40 bottom right The flower-flecked fields of Connemara and the Co. Galway coast often run down to broad sandy beaches.

40-41 A melancholy, almost wild landscape of bog, water and bare hills, typical of Connemara National Park, Co. Galway.

41 top Maam Cross, a starting point for the Joyce Country and Connemara, Co. Galway, offers visitors both traditional and modern pubs and hotels.

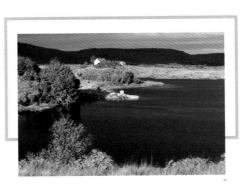

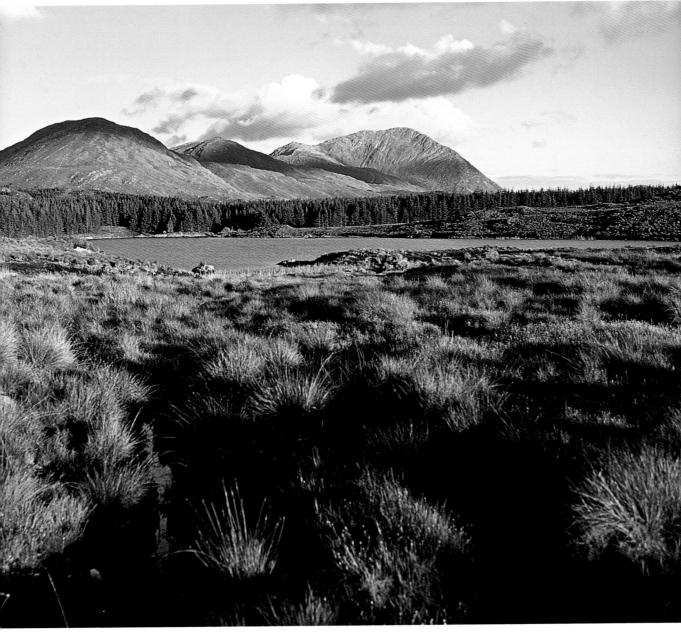

The rugged landscape continues in County Mayo to the north.

Here we see evidence of the effects of the Great Famine, prompting emigration that continues today, because this remote region, though beautiful, is not economically sustainable.

Nonetheless, the physical beauty of the mountains, headlands and bays remains a powerful magnet for both Irish and other visitors.

ing 2,500 feet/762 metres. In 441, St Patrick fasted here for forty days, praying for his countrymen, who honour him still with a popular annual pilgrimage, often undertaken barefoot.

To the northwest lies Achill Island, hilly, heather-clad, offering a melancholy beauty, expansive beaches and fine sea-fishing — sharks an attraction!

Inland lies Lough Conn, in a gentler and at times bleak landscape that continues

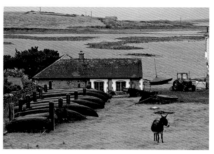

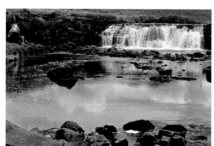

Lough Corrib, lying inland, draws many of them: just south of the small town of Cong is Ashford Castle, a massive structure in the Gothic Revival style of the 1870s, now a luxury hotel.

Northwest, in Clew Bay, is spectacular Croagh Patrick, an isolated conical peak ris-

north to the coast through a region of small farming. On the north coast extend the Céide Fields, where turf cutting has revealed stone walls marking part of a series of Stone-Age fields, extending over some 4 sq miles/10 sq km. The remains suggest a remote life of hardship.

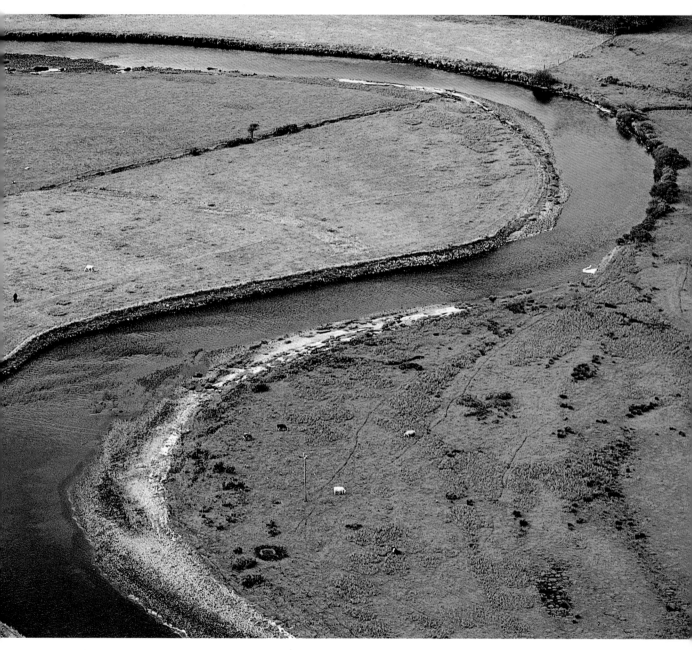

42 top Blacksod Bay, Co. Mayo, with the well-watered terrain showing both grassy and bracken-clad areas.

42 centre left This wide-angle shot captures the blue waters, clean sandy beaches, meadows and cottages of the remote Blacksod Bay area of Co. Mayo.

42 centre right Westport Bay, Co. Mayo, presents both traditional and modern Ireland: a 'parking lot' for currachs, a donkey and a tractor.

42 bottom left Bunatrahir Bay, not far from Ballycastle, Co. Mayo, attracts surfing enthusiasts when winds and tide are right.

42 bottom right The wild and beautiful Aasleagh Falls on the Erriff river, Co. Mayo, just above Killary Harbour.

42-43 The gentler terrain of Co. Mayo. Here a river winds through rich meadowland toward its estuary in Blacksod Bay.

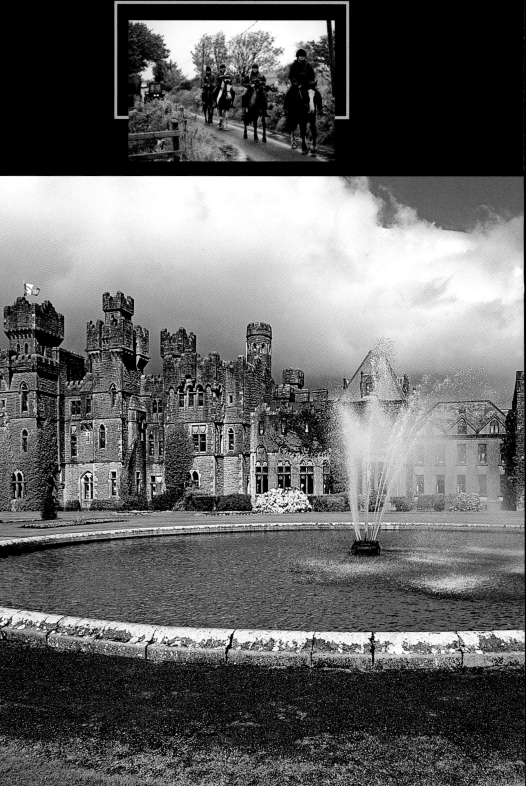

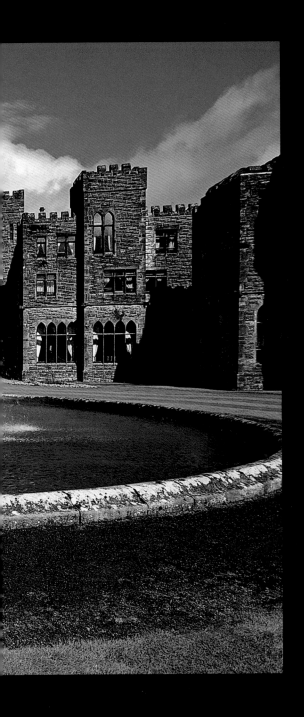

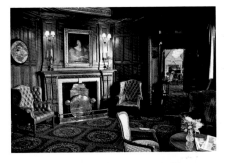

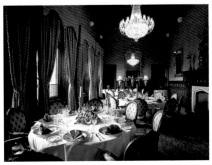

44 top With much of Ireland's population still happy to be astride a horse, motor vehicles invariably yield right of way, as here in Co. Mayo.

44-45 Ashford Castle on Lough Corrib, Co. Mayo, celebrates the 1870s Gothic Revival style. Once a Guinness family home, it is now a luxury hotel.

45 top Rich Victorian furniture and panelling add solid comfort to an escapist stay in the vast Ashford Castle luxury hotel near Cong, Co. Mayo.

45 bottom Fine cuisine beneath brilliant chandeliers in handsome Victorian period dining salons is all part of the Ashford Castle experience.

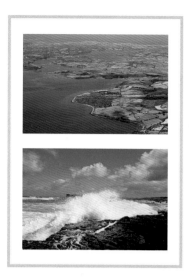

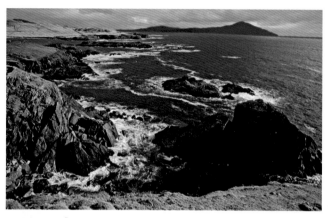

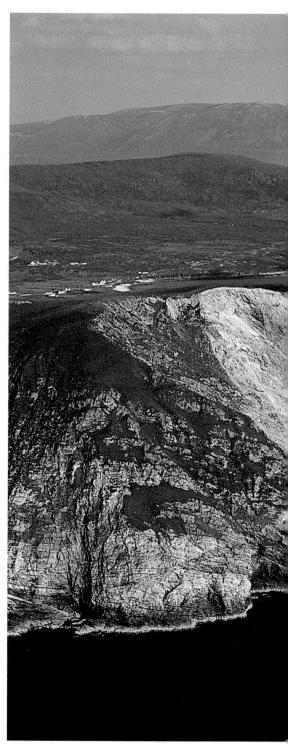

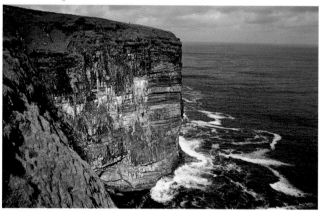

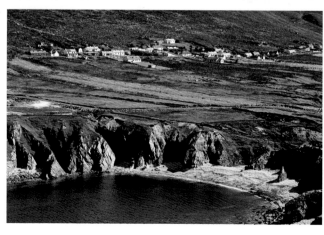

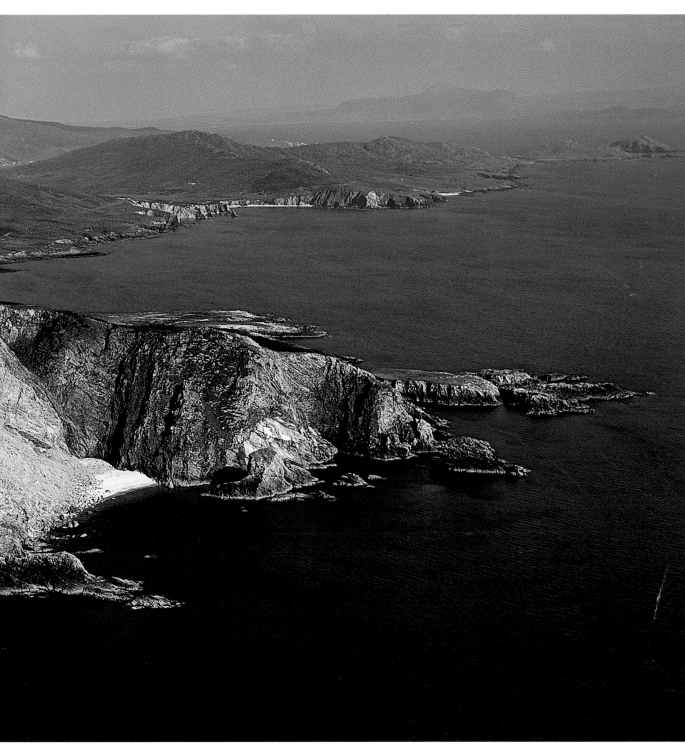

46 first photograph Downpatrick Head on Co. Mayo's northeast coast reflects the typical mix of crop and grazing lands, woods and water, and cliff and beach.

46 second photograph Though often offering inviting beaches and gentle landscapes, the Co. Mayo coastline has its bleaker, rockier stretches.

46 third photograph Achill Island's rocky coasts and unfenced hills hint at land often too poor for farming. It now draws holiday visitors and hikers.

46 fourth photograph Between inland hills and this Co. Mayo coast lie the Céide Fields, more than 4 sq miles/10 sq km of walled Stone-Age fields, many preserved beneath bogs.

46 fifth photograph Fish and fowl draw naturalists and sportsmen to rugged Achill Island, Co. Mayo, where deserted villages bear witness to the Great Famine.

46-47 Blacksod Bay, Co. Mayo, with the nearby towns of Westport and Newport, in an area rich in wildlife.

To the east lies County Sligo, with the Ox Mountains at its west.

The flatter central region and the low hills characterised by plateau-like tops give way to beaches, often sheltered below modest headlands.

Though seldom dramatic, the inland scenery is quietly varied. Lough Gill, with its 'Lake Isle of Innisfree', enchanted William Butler Yeats; brooding Ben Bulben is the backdrop to his grave in Drumcliff churchyard.

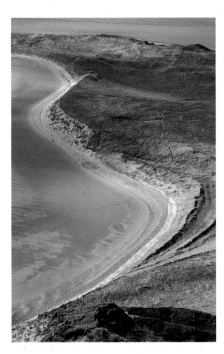

48 top left Lough Gill, Co. Sligo, 'the heart of the Yeats Country' with its 'Lake Isle of Innisfree', Dooney Rock and Parkes Castle, pleases every visitor.

48 top right A lonely lighthouse on a lonely islet in Sligo Bay warns shipping of shallows and rocks.

48 bottom left Sligo Bay's broad beaches and, not far inland, the famous Carrowmore Megalithic Cemetery with its remarkable tombs, draw many visitors.

48 bottom right Starkly beautiful Sligo Bay is sufficiently exposed to experience heavy North Atlantic storms in the winter months.

48-49 Dating from the 17th century, Parkes Castle on Lough Gill, Co. Sligo, offers everything: towers, turrets, crenellations and battlement walks.

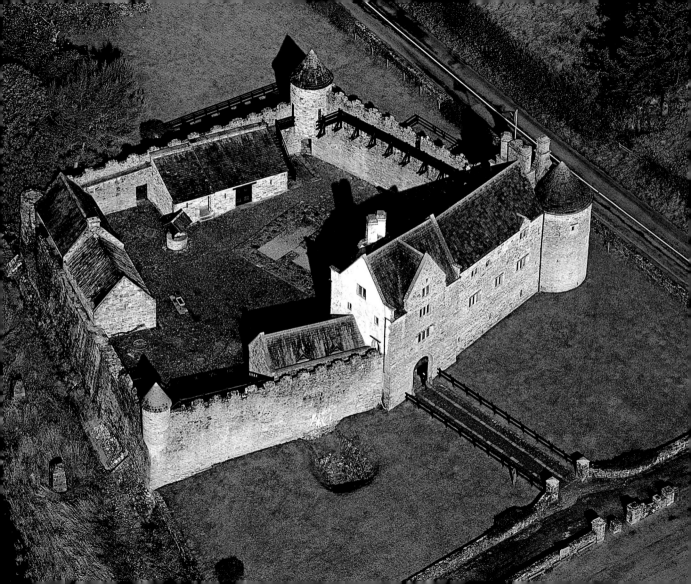

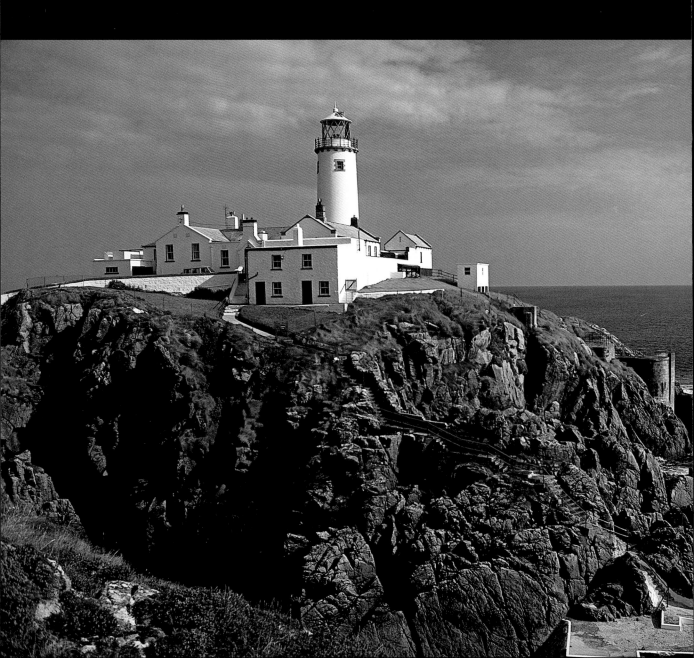

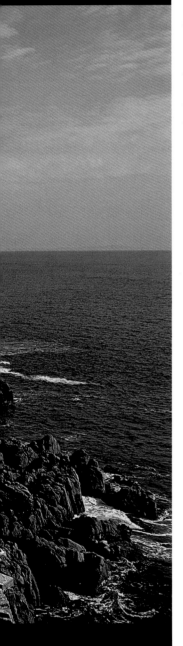

Wilder and more romantic scenery returns with mountainous County Donegal. Here, the rugged flanks of tangled ranges conceal numerous lakes and valleys. The county offers something for everybody: climbing, hiking, shooting, fishing, walking, watching wildlife, or just enjoying the ever-changing sea- and sky-scapes. Most visitors are struck by the remoteness of Donegal, its rockiness and poor soil (once richer, as evi-

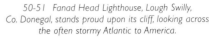

50-51 Fanad Head Lighthouse, Lough Swilly, Co. Donegal, stands proud upon its cliff, looking across the often stormy Atlantic to America.

51 top left Slieve League, southwest Co. Donegal, where the cliffs, Europe's highest and most dramatic, rise almost 2,000 ft/610 m from the sea.

51 top right This view of Malin Head, northeast Co. Donegal, captures the rugged grandeur of the cliffs and the bleak landscape atop them.

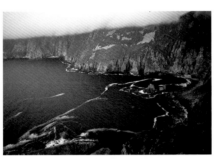

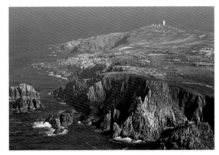

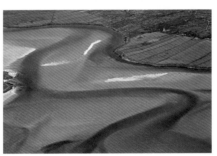

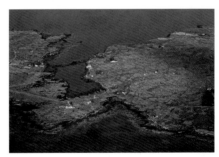

denced by its numerous Celtic sites) and intense 'Irishness' – it has a large Gaeltacht area. At Slieve League an immense 1,800-foot/549-metre high cliff rears up, while the coast is of unique dramatic vistas. The Rosses in the northeast sets another record – for its number of small lakes! Just off the coast is Arranmore Island (also called Aran, like its Galway cousins), which offers challenging cliff walks.

51 bottom left The Gweebarra River in western Co. Donegal winds through a landscape of fertile fields and whitewashed farmhouses.

51 bottom right The Rosses, a great headland in western Co. Donegal, claims more than 100 lakes. The small stone-walled fields are typical of the region.

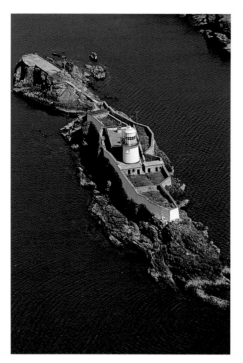

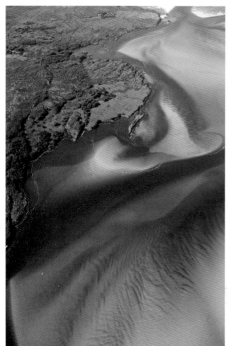

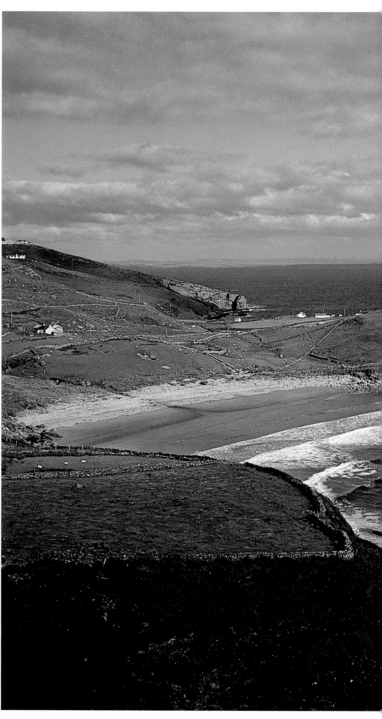

52 top The fortresslike walls of Killybegs Lighthouse,
Donegal Bay, guard it against storms. It guides ships
into the busy, attractive port of Killybegs.

52 bottom The scenic Gweebarra River winds into
the bay to which it gives its name. Sandbars and
shoals change with the tides.

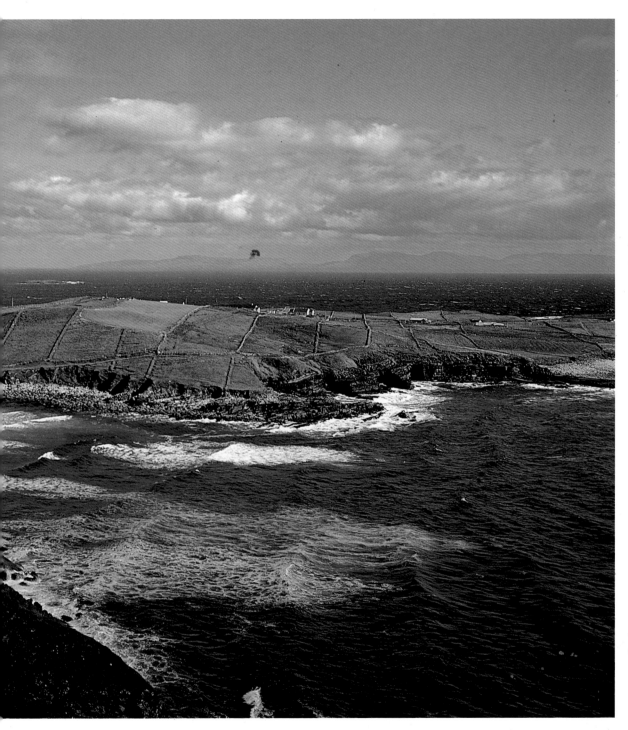

52-53 *McSwyne's Bay is typical of the gentler stretches of the Co. Donegal coast, with its coves, carefully farmed fields and traditional cottages.*

53 bottom *Co. Donegal's sandy beaches are tranquil and inviting in summer: in winter, Atlantic storms may batter them.*

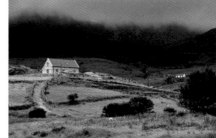

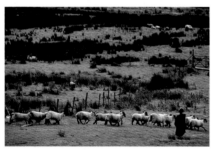

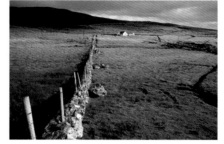

54 top left A rural scene of grazing sheep, stone walls and sheltering trees in Headfort, Co. Galway.

54 top right A typical landscape near Tellin Bay, Co. Donegal, with threatening clouds behind.

54 bottom left Owenwee valley, Co. Donegal. The land provides good grazing for sheep, but the high water table means that sedges and water grasses abound.

54 bottom right A Co. Donegal farm where old and new combine; dry-stone walls are supplemented by post-and-wire fencing.

54-55 Cottages and narrow lanes characterise Bloody Foreland, in Co. Donegal.

55 top left A typical scene in Co. Donegal. The decayed vegetation burns with a pleasing fragrance.

55 top right Glencolumbkille, with its colourful cottages and associations with St Columba, takes pride in the Folk Village Museum.

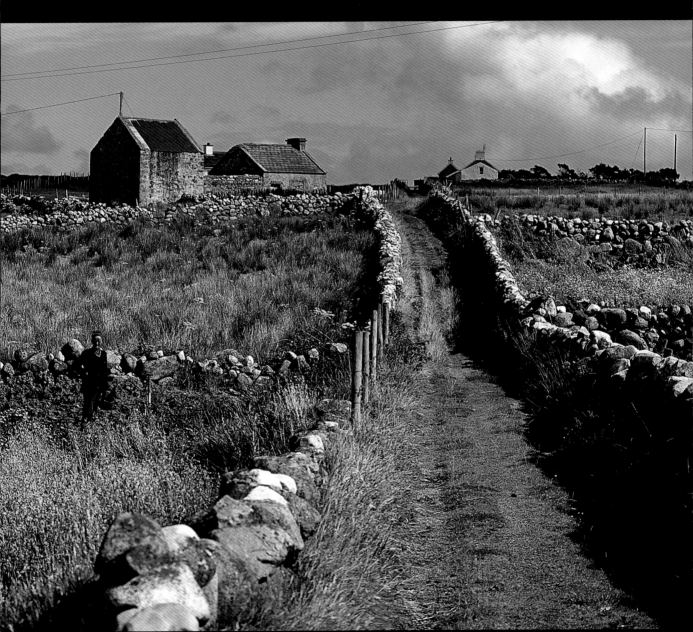

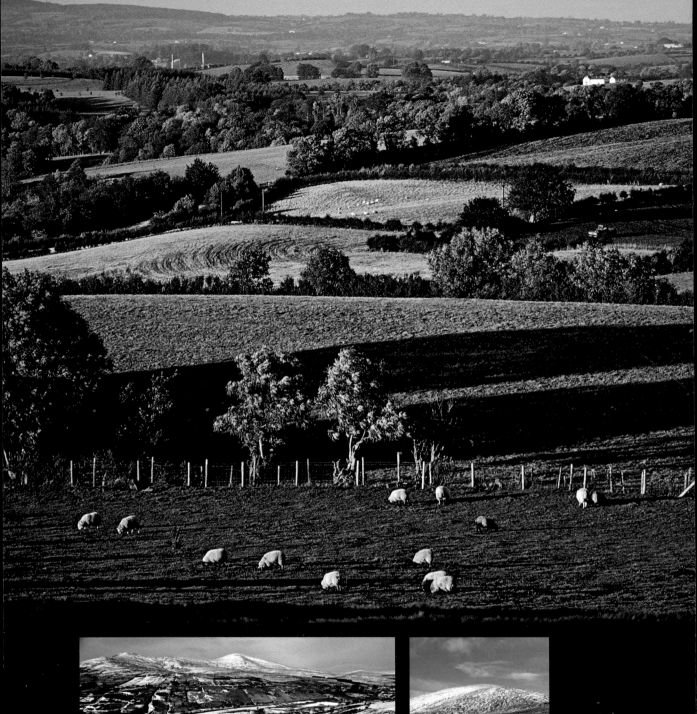

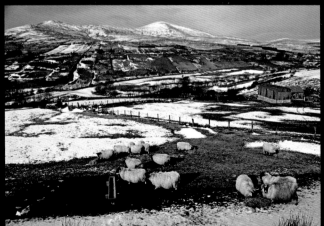

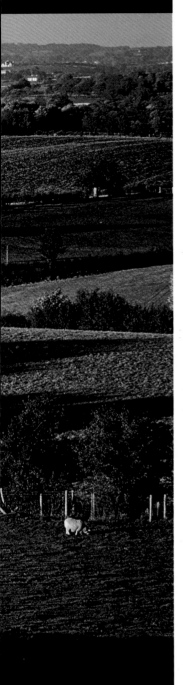

Inland to the east, in Ulster (Northern Ireland), less rugged country prevails. County Tyrone is known for its fertile river valleys and glens and gentle landscapes, with a hillier region to the north towards County Derry. Marking the coast are three much-loved attractions.

Sited on a magnificent cliff-top near Castlerock is Mussenden Temple, a small

some of the castle now resides in the ocean depths below . . .

Those with a head for heights will want to cross Carrick-a-Rede bridge, a frail span high above the waves.

Inland and to the south the extensive wetlands around Lough Neagh (Ireland's largest lake) are home to varied birdlife and are a magnet for ornithologists.

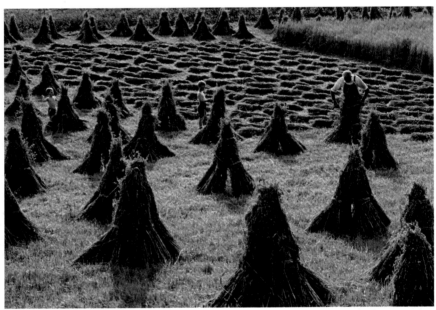

circular and domed memorial chapel commissioned by Augustus Hervey, Bishop of Derry, a peripatetic bishop after whom the Hotel Bristol, found in many European cities, is named, reflecting his title of Earl of Bristol.

Farther along the coast is the great roofless ruin of Dunluce Castle, begun in the 13th century.

Its cliff-top site is a little too dramatic:

Those who are drawn to history can visit two fine permanent exhibits, the Ulster-American Folk Park in County Tyrone and to the east, in County Down, the Ulster History Museum. Both feature restorations of the homes, tools and life of earlier times. Archaeology enthusiasts will enjoy the extensive Neolithic stone circles in their grass and bracken setting at Beaghmore in County Tyrone.

56-57 Co. Tyrone, well-watered and well-wooded, is home to mixed farming. Hedges rather than stone walls predominate.

56 bottom left Sheep show surprising hardiness and self-sufficiency in winter. These are grazing in the lee of the Sperrin Mountains, Co. Tyrone.

56 bottom right A lone hiker heading toward Mount Sawel, in the Sperrin Mountains, Co. Tyrone. Ireland in winter can be bare, brown and bleak.

57 A farmer setting up sheaves to dry, providing temporary habitats for corncrakes and other birds.

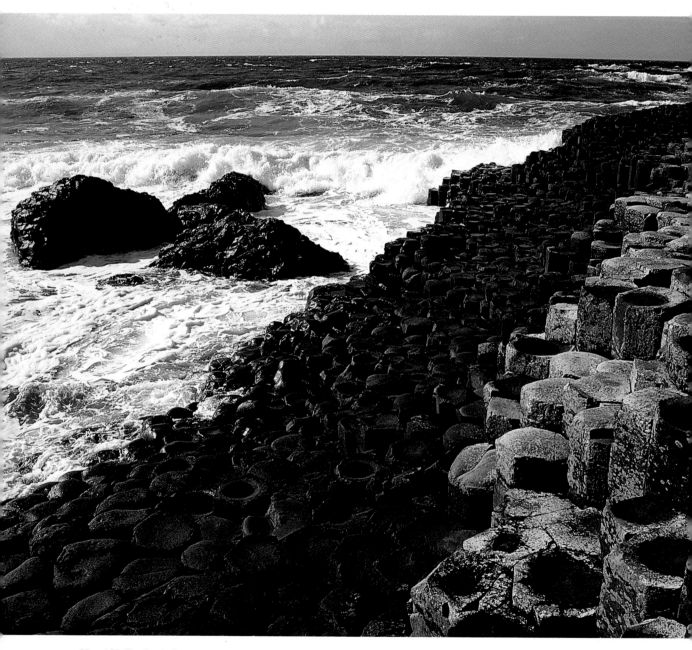

58 and 59 The Giant's Causeway is a mass of basalt columns packed tightly together. The tops of the columns form stepping stones that lead from the cliff foot and disappear under the sea. Altogether there are 40,000 of these stone columns, mostly hexagonal but some with four, five, seven and eight sides. The tallest are about 40 ft/12 m high, and the solidified lava in the cliffs is 90 ft/27 m thick in places.

60 and 61 The entire coastline around the north-eastern part of Ireland is a succession of majestic headlands and spectacular bays. This part of Ireland once formed the ancient Kingdom of Dalriada, a realm of rounded mountains and deep glens, stark sea cliffs and white beaches. The region, which is steeped in history, legend and folklore, fits at the same time everybody's ideal of nature unspoiled.

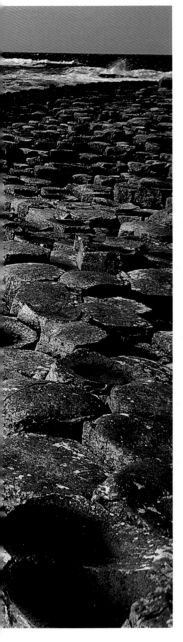

Ulster's most famous attraction is on County Antrim's north coast: the natural phenomenon of the Giant's Causeway. Not just a single proliferation of hexagonal basalt columns as often shown, but three major masses, with columns of numerous different configurations. Formed some sixty million years ago from cooling basaltic lava from volcanic eruptions, and eroded by ice, wind

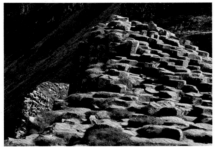

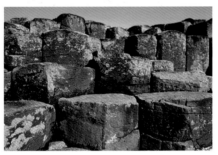

and sea, the rock shows a reddish tint from a layer of iron-rich ore. In contrast, the Glens of Antrim, valleys opening towards the coast, are remarkable for their gentle contours and well-watered greenness.

Beyond Fair Head on Ulster's northeastern shoulder, a handsome stretch of coast begins, backed by the Antrim Mountains running down to the North Channel, with the tip of Scotland's Mull of Kintyre only 15 miles/24 km away. Glenarriff Forest Park lies inland, an area of concentrated beauty with marked trails leading to wooded high ground, glens and small rivers.

South beyond Belfast Lough lies another beautiful and often dramatic stretch of coast where the Ards Peninsula thrusts southwards, with sheltered Strangford Lough inland. Proximity to Belfast makes the peninsula a popular amenity for the city's residents, with Bangor marina serving sailing en-

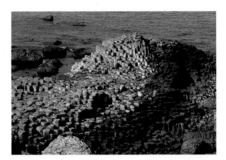

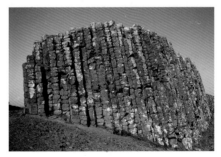

thusiasts, and Scrabo Park, with its curious turreted tower, offering leisurely walks. The mix of picturesque coast backed by gentle hills continues in the broader, blunter Lecale Peninsula. Here the rounded, worn and sometimes bleak 'Mountains of Mourne' (as Percy French's song calls them) enfold the sombre Silent Valley, then 'sweep down to the sea' – to the delight of poets and painters! Traditional small farms and cottages dot the scenic valleys. South lies Carlingford Lough, the starting point of this circular tour.

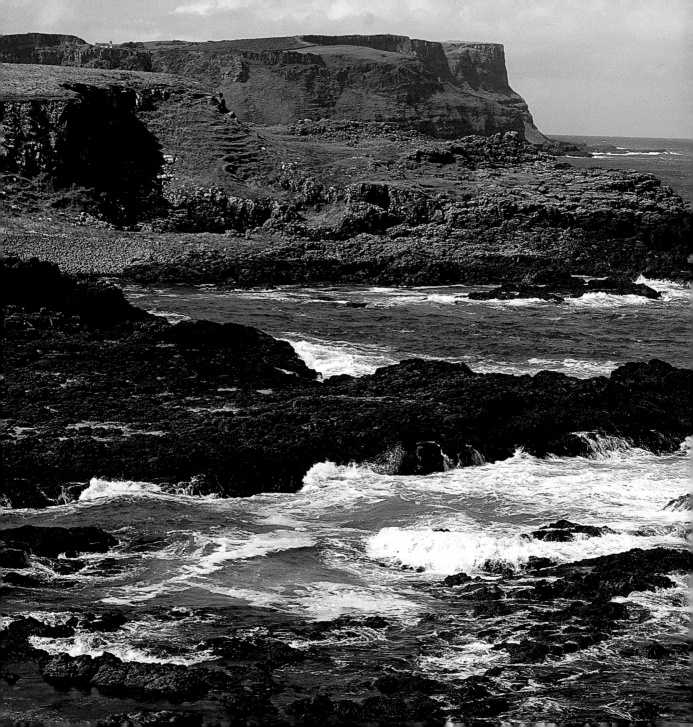

Compared to the coastal regions, the centre of Ireland has an overall gentler scenery with a quieter, sometimes melancholy beauty as farmland gives way to areas of bogland and turf cutting. Much of the region is a plain, and through its western flank flows the Shannon whose source lies to the north of Lough Allen.

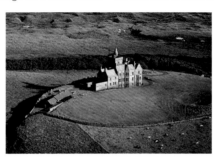

Just to the south of County Leitrim, the Shannon-Erne Waterway gives the Shannon a north-eastern connection to both Upper and Lower Lough Erne, from which the River Erne flows into Donegal Bay.

The Waterway is a restored Victorian canal, long abandoned as a route for transporting goods. Today it offers leisurely cruising – as well as an education in Victorian skill in lock and bridge construction! Starting in the north, the visitor can enjoy the beauties of Lower Lough

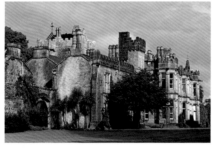

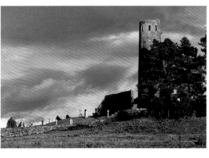

Erne, with its many islands and peninsulas, including some remains of early monastic settlements.

Upper Lough Erne is far smaller but offers many of the same rewards, particularly fishing and wildlife. Near the junction of the lakes are the Marble Arch Caves, where a boat trip carries us into a silent world of stalactites and stalagmites.

There is a surprising number of great country houses in the vicinity of these lakes, among them Crom Castle, Castle Coole, Monea Castle, Tully Castle and the magnificent Florence Court.

Farther south is Lough Ree, famous for its eels and known for its ragged shores littered with small islands and inlets. Waterfowl and wildlife abound and the lake offers many lonely stretches of quiet beauty. Some 10 miles/16 km below Lough Ree, on the banks of the Shannon in County Offaly, stands Clonmacnoise, one of Ireland's most evocative sites. Though the churches and most buildings within its walls are roofless, the standing towers, Celtic crosses and graves reflect a distant past. Clonmacnoise in its tranquil green setting evokes all the glories of early Christian Ireland. It is impossible not to be deeply moved, aware of the destruction that the pagan Vikings wrought on the God-fearing Irish. Further south, a later, secular tradition is reflected in Birr Castle. This lived-in castle with its fine formal and river gardens has for four hundred years been home to the Parsons family, known for producing scientists and inventors; astronomical telescopes and the steam turbine are among their best-known contributions.

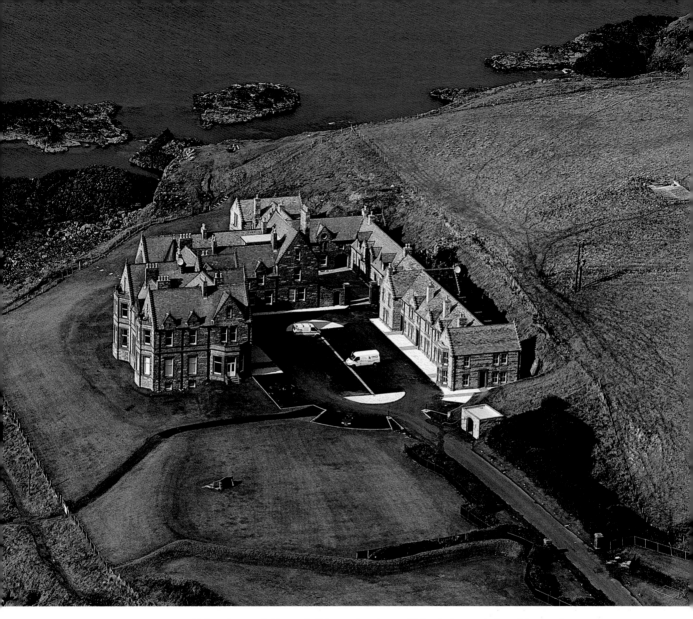

62 first photograph Here in Co. Westmeath, in the heart of Ireland, the broad River Shannon winds lazily through lush farmlands.

62 second photograph The ruins of once secure Clonmacnoise Castle, Co. Offaly, bear witness to the vicissitudes of time and fortune.

62 third photograph The isolated fortified manor house in Co. Sligo, complete with round tower, was once the home of Lord Mountbatten.

62 fourth photograph One of the most famous owners of Tullira Castle in Co. Galway was Edward Martyn, poet and patron of the arts in the 17th century.

62 fifth photograph The Round Tower at Clonmacnoise, Co. Offaly, was built as a place of protection for the monks who often faced Viking raids.

62-63 This fine late Victorian mansion fronts the Atlantic; however the humbler rear wing enjoys the shelter of the hill.

CITIES
AND TOWNS

Ireland's cities and towns are remarkably rich in history. The majority have a castle, often partly or in ruins. Much of the destruction occurred when Cromwell and his armies undertook a near-psychopathic destruction of Catholic Ireland. William of Orange continued the brutal depredations in the years 1689 to 1691, after the hapless James II, deposed in England, rallied Catholic Ireland to his cause. A number of Irish cities and towns retain parts of their old city walls. In the case of Londonderry, the tlers under the 'plantation' policy. These often reflected a standard Gothic style known as Planters' Gothic. Most are rather modest in size: though Protestants dutifully served God, many more willingly served Mammon. Despite the destruction caused by Vikings, Anglo-Normans and the English, many Irish cities display architecture ranging from the early Christian centuries to the Georgian and Victorian periods. Visitors will be struck by the careful restoration of numerous historic buildings. Modern architecture makes its appearance,

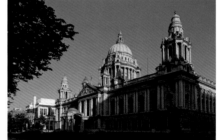
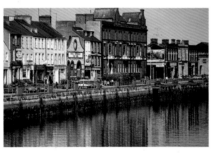
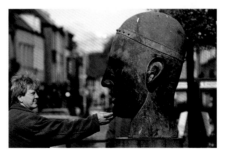

ancient walls are entirely intact; they offer unrivalled views of the city's historic centre and newer areas beyond. Every Irish city and town has its Catholic church; most have several. Quite a few are relatively modern, having been built in the 19th century or later after Britain grudgingly embarked upon partial emancipation for Irish Catholics. Built in a spirit of defiant optimism, some cathedrals and churches are truly immense, as in Athlone and in Cobh. Ironically, many Protestant churches, particularly in Ulster, were built in the 17th century following expulsion of the native Irish from selected areas to provide land for the incoming English and Scottish Protestant set- sometimes with sensitivity and discretion. With the exceptions of Dublin, Belfast and Londonderry, Ireland's cities and towns are small enough to be easily explored on foot. What delights visitors in Irish cities and towns are stylish shops, fine restaurants and attractive pubs together with efficient services, comfortable accommodation and great recreational facilities. Warm welcomes and easy conviviality are found everywhere: though the Irish live very much in the contemporary world, they nonetheless manage to hold onto a noticeably relaxed life style in which the pub, with its conversation and humour, is a worthily celebrated institution.

64-65 *Through the city's growth, the residential areas of Dublin have kept a good realationship with nature.*

65 top *In a town like Londonderry the different kind of shop-signs, written either in English or in gaelic, can signify political bias.*

64 top left *Colourful houses, each one with its own bow window instead of a balcony, are essential ingredients for a typical Irish urban street.*

64 bottom left *The River Lee and its canals build a water network that covers the city of Cork like a second road system.*

64 top right *The city hall of Belfast is an imposing building that dominates the city, thanks to its 174 ft/53 m high dome.*

64 bottom right *A man touches friendly St Canice's chin on Parliament Street, Kilkenny. The sculpture represents the patron saint of the city.*

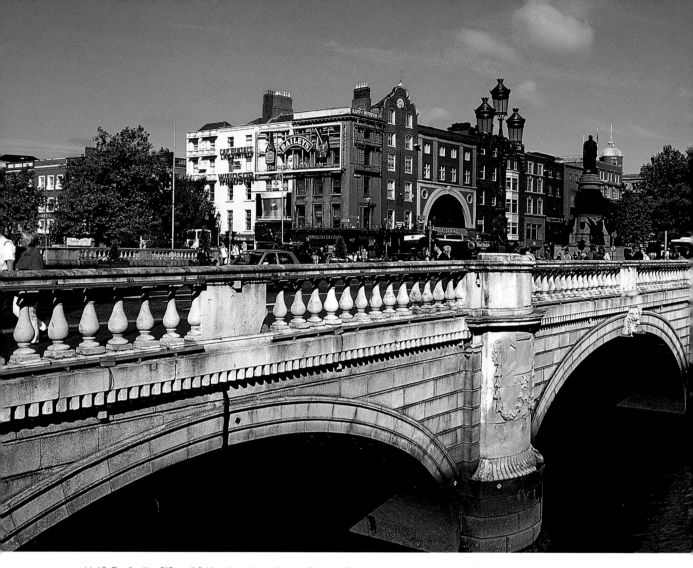

66-67 The familiar O'Connell Bridge, the main north-south crossing over the River Liffey.

67 top The famous Ha'penny Bridge (named after its original crossing fee) connects Temple Bar to Liffey Street.

67 centre The classical drum and rotunda of the Four Courts building, which flanks the Liffey at Inns Quay.

67 bottom The classical Custom House (built 1781-91) was set fire to in the War of Independence, 1921. Fully restored, it now houses government offices.

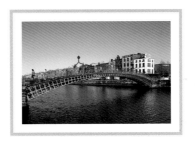

DUBLIN RICH IN ARCHITECTURE

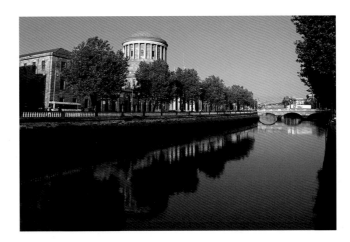

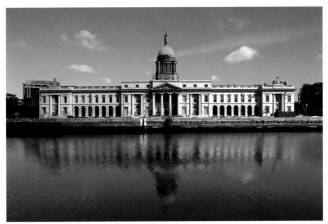

Dublin, Ireland's capital, is the visitor's natural starting point. It dates back to 841, when the Vikings founded a small settlement on the River Liffey. The river divides the older southern section from the newer, largely 18th-century northern part. Many architecturally significant public buildings are to the south, though both sections offer numerous buildings and residential streets. For many visitors Dublin's finest façades, buildings and squares are those of Trinity College, which possesses extraordinary treasures, including the Book of Kells, a masterpiece of Celtic illumination. Dublin

Castle, with its mixture of centuries and styles, long symbolised British rule, but now draws visitors to its elegant Throne Room, magnificent State Apartments and the stunning St Patrick's Hall. Not be missed is the National Museum on Kildare Street, in eclectic Neo-Classic style boasting a rotunda above a magnificent zodiac floor; it is strikingly rich in early Celtic treasures – the Tara Brooch, the Gleninsheen Torc, the Crucifixion Plaque and the Broighter Gold Boat. Collections cover all of Irish history, and a special section covers the 1900–1921 period and the establishment of the

68 top A handsome building in Dame Street. This street name derives from the dam built across the River Poddle in ancient Dublin.

68 centre left The statue of Daniel O'Connell dominates the approach to O'Connell Bridge (foreground); Abbey Street runs below the two cupola'd buildings in rear.

68 bottom left The Fusiliers Arch stands at the western entrance to St Stephen's Green, its classical lines a contrast with the modern building at left.

68 bottom right O'Connell Street and the statue honouring Daniel O'Connell (1775-1847), 'the Liberator', who in 1828 won partial emancipation for Irish Catholics.

69 Topped by a copper cupola, Dublin Castle's Bedford Tower is a much-loved landmark.

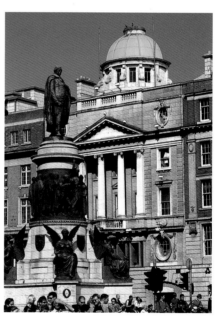

Irish Free State. The National Gallery on Merrion Square exhibits not only Irish artists but also European masters of the major schools, and has a fine Caravaggio: The Taking of Christ. The National Library on Kildare Street (built in 1890) is a magnet for all who love Ireland's great writers, and there is no finer place to study them than in the great domed Reading Room. Dublin's cathedrals reflect the nation's religious history. St Patrick's (Church of Ireland), first rebuilt in stone in the 12th century, has been much added to over centuries. Visitors will note the lancet windows and, inside, the choir, and memorials to Dean Swift and to the Boyle family. Christ Church Cathedral (Church of Ireland), also rebuilt in the 12th century, was substantially restored in the 19th century. It is known for its impressive crypt, soaring nave and for Strongbow's tomb. St Mary's Pro-Cathedral, Dublin's main Catholic church, was not encouraged by the Protestant British when completed in 1825, but the somewhat hidden Neo-Classical structure has a white-and-gold nave and an enviable reputation for choral excellence. Merrion and Fitzwilliam Squares, with their fine Georgian houses, Grafton Street and O'Connell Street, and Dublin's uniquely rewarding pubs, will charm any visitor. A must for James Joyce enthusiasts is the Joyce Tower and Museum in Sandycove, and the local trips that follow his wanderings. For relaxation, there is the tranquil haven of Phoenix Park; at 1,750 acres/708 hectares it is Europe's largest. And for a perfect Neo-Classical gem there is the Casino at Marino.

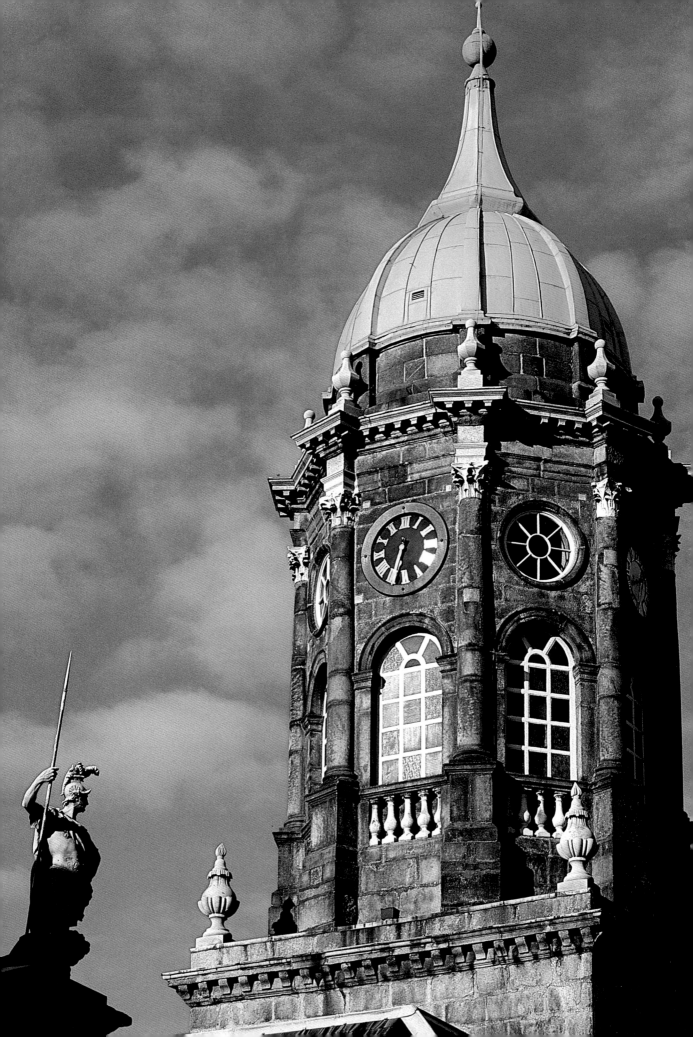

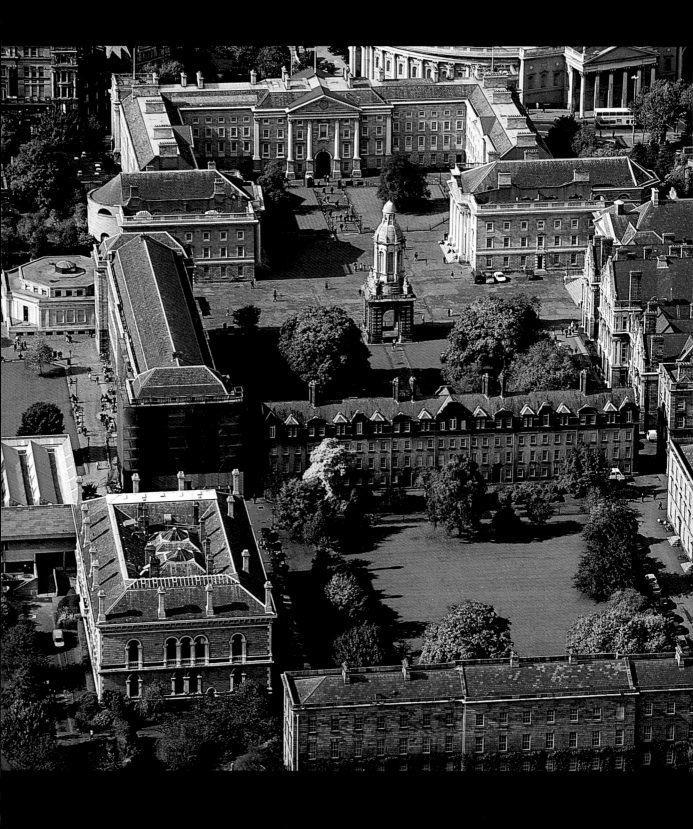

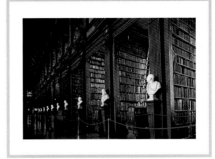

70-71 *Trinity College, looking from the Campanile (centre) across Parliament Square toward the columned main entrance. Library Square and New Square are in the foreground.*

71 top *The Old Library, Trinity College. Over 200 ft/61 m long, it houses over 200,000 books and manuscripts, many uniquely valuable.*

71 centre top *This attractive bridge links Christ Church Cathedral to its Synod Hall, which is now a museum presenting medieval Dublin.*

71 centre bottom *Memorial statues of Irish worthies in St Patrick's Cathedral, Dublin. The cathedral also commemorates Jonathan Swift.*

71 bottom *St Patrick's spacious nave, looking toward the altar, hints at the cathedral's size: it is Ireland's largest church.*

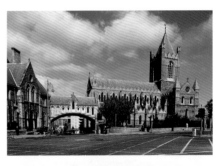

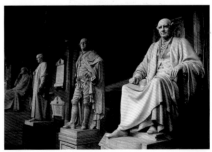

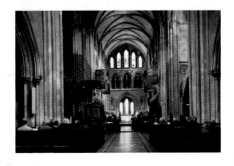

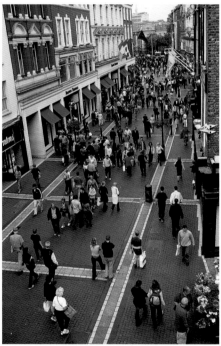

72-73 *Grafton St is for pedestrians only and always crowded, a home to cafés, galleries and street entertainers.*

72 bottom left *Flower stands add colour to busy Grafton St, now known for its fashionable shops and 'in' restaurants.*

72 bottom right *A walk in Grafton St is always a good excuse to go shopping in one of the many boutiques and shops.*

73 top *The James Joyce statue by Marjorie FitzGibbon enhances North Earl St.*

73 bottom *Grafton St's natural curve, its varied building façades and patterned roadway, add to its charm.*

74 top A number of beautifully restored establishments in central Dublin's streets elegantly display beverages for every taste . . .

74 centre left A relaxing drink or two is one thing, but bartenders recognise the often-needed restorative effect of a strong coffee.

74 centre right Dublin's drinking establishments range from the poky (though no longer smoky) to the grand, which also offer quiet alcoves.

74 bottom left For the restrained, the Long Hall's ornate yet substantial interior adds respectability to drinking.

74 bottom right Successful bartenders learn not only the characteristics of drinks but also the varieties of the human temperament.

74-75 Mulligan's Pub, a milestone of good drinking since it was set up in 1782, and famous for its beers, draws both locals and visitors.

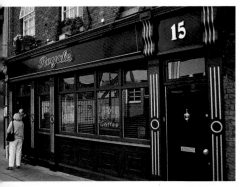

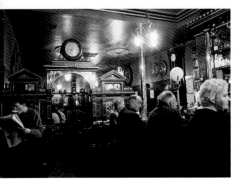

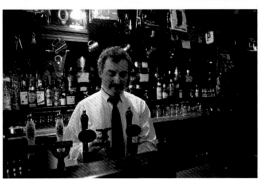

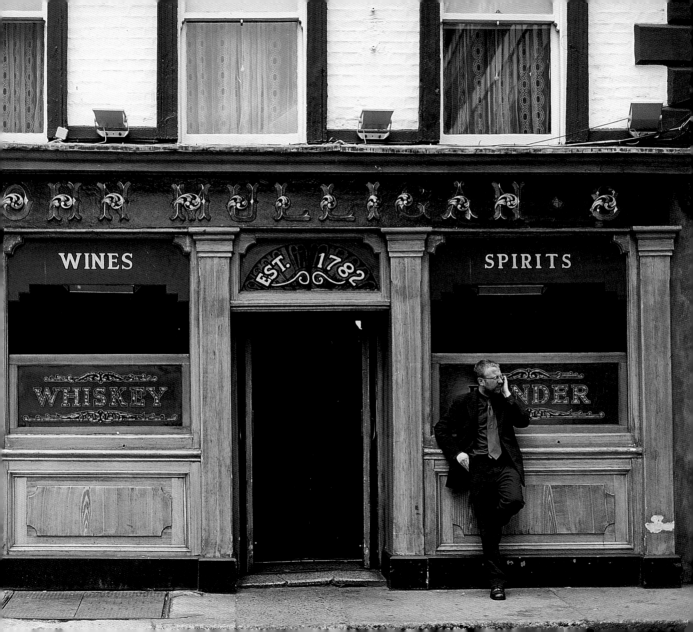

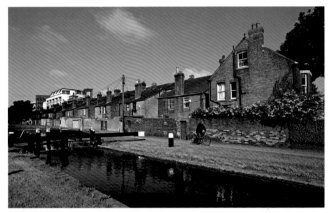

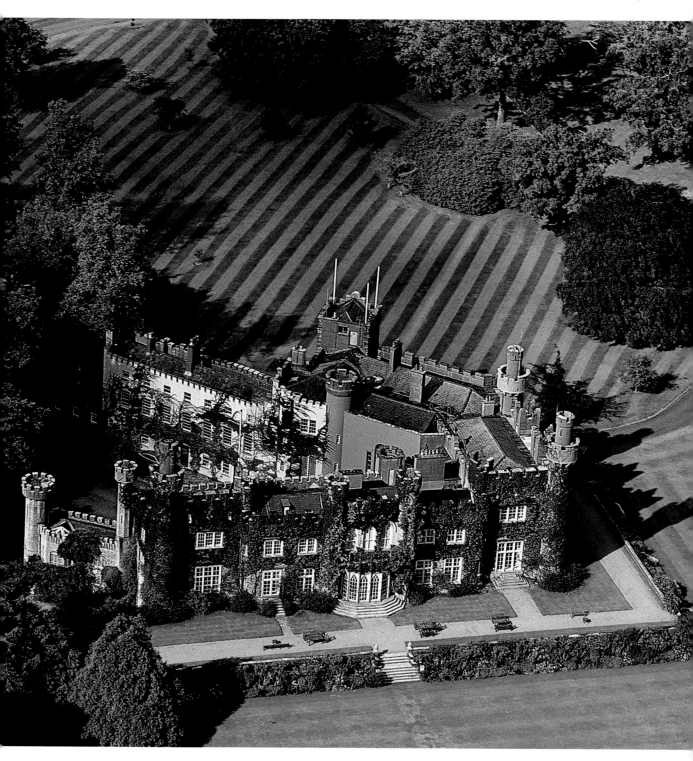

76 first photograph Many Dublin houses date from
the Georgian period; flat façades relieved by handsome
doorways and windows marked by fine detailing.

76 second photograph Two adjoining Dublin houses
present façades of distinctly different proportions and
details; both are pleasing.

76 third photograph Dublin's Grand Canal doesn't
appear very grand but is an added amenity for the
modest homes that back onto it.

76 fourth photograph In addition to numerous leafy
squares, Dubliners have the huge Phoenix Park,
complete with gardens, lakes and a zoo.

76 fifth photograph A moist, gentle climate does
much to guarantee leafy shady trees and springy
green grass in Dublin's parks.

76-77 15 minutes by car far away from Dublin,
Luttrellstown Castle and its 494 acres/200 hectares
of park, evoke a fairy-tale atmosphere.

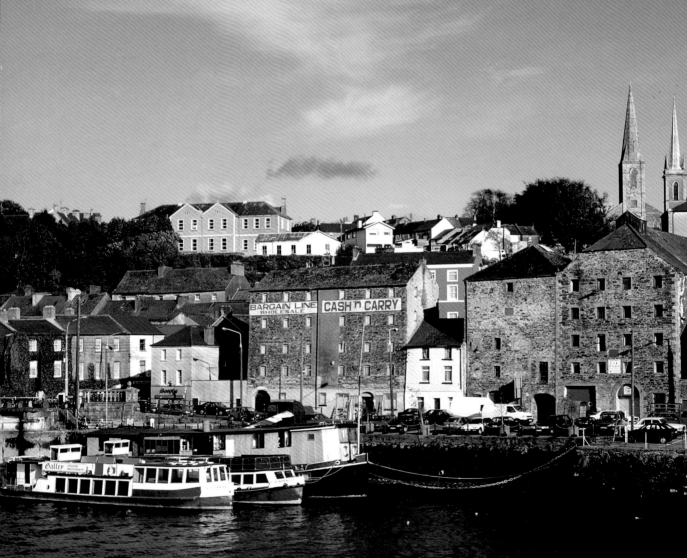

WEXFORD
THE VIKING PORT

Far south of Dublin, but sharing the same coast, is the attractive town of Wexford. Located in the sheltered estuary of the River Slaney, it was once a busy port linked to Wales and England.

Now with its harbour silted up, the town's economy draws upon its modest shell-fishing industry and tourism.

Little remains of Wexford's Viking origins

The towns caters for the young with its lively bar scene, and for the musical with its international Wexford Opera Festival held every October. Wexford's nearby attractions include the Wildfowl Reserve in the Slaney estuary, and a few miles away stands the multi-towered, machicolated, crenellated Johnstown Castle, an exuberant 19th-century structure with the Irish Agricultural Mu-

 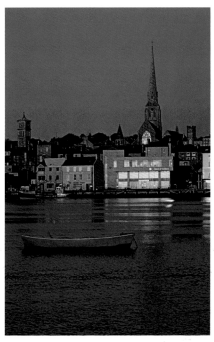

other than the herring-bone pattern of small alleys coming off Main Street, and part of the town wall featuring a medieval gateway. Adjoining it are the ruins of the 12th-century Selskar Abbey.

seum in its grounds. Two miles/3 km away is Rathmacknee Castle, largely a ruin, but some fine 15th-century battlements are intact. Just south of Wexford is sunny Rosslare, known for its broad beaches.

78 top Wexford Town Bridge. This crossing was the scene of fierce fighting in the United Irishmen's uprising of 1798.

78-79 Though home to a number of mussel-dredgers, the attractive Wexford harbour and town thrive mainly on visitors.

79 left The Bull Ring in Wexford features this statue of a solitary pikeman; it commemorates Wexford's role in the 1798 rebellion.

79 right A solitary boat, waterfront buildings, a tower and a church steeple in Wexford town are caught in dawn's early light.

WATERFORD
THE OLD CITY

Waterford, on the south coast, is Ireland's oldest city, founded by the Vikings in 914. Today the Watch Tower and the squat, thousand-year-old Reginald's Tower (housing a museum) and sections of Viking wall indicate the strength of the city's ancient defences. Waterford remains a busy port, and has done much to reinvent itself as a historic centre. Buildings on the magnificent quays

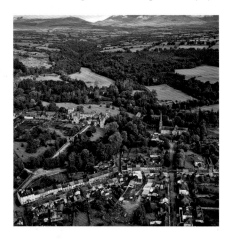

fronting the River Suir have been renovated, and the Georgian houses on the inner streets have been restored. Holy Trinity Cathedral is built in the severely Neo-Classical style, and Christ Church Cathedral exclusively in the Neo-Classical Georgian style in 1770 and featuring a striking steeple and the remarkable tomb of James Rice. The Historical Museum and Chamber of Commerce, originally a private house, are both handsome buildings. The traditional Waterford crystal continues to be manufactured in a modern factory on Waterford's outskirts. County Waterford's great attractions include both its Festival of Light Opera and picture-perfect Lismore Castle, set on a ridge above the River Blackwater.

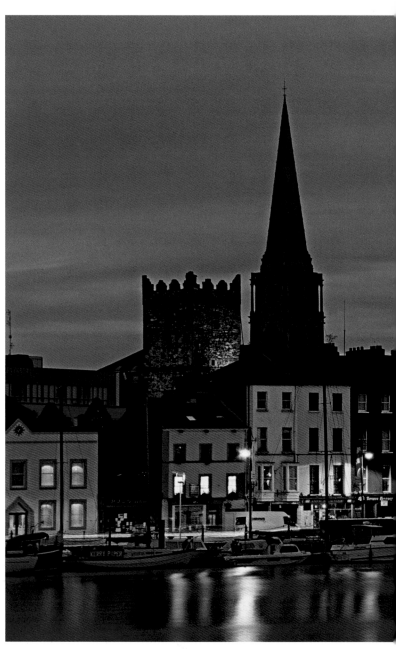

80 left Lismore Castle, Co. Waterford, the palatial Irish home of Britain's Duke of Devonshire.

80-81 The Quay fronting the River Suir in Waterford; behind the houses, Christchurch Cathedral's spire soars skyward.

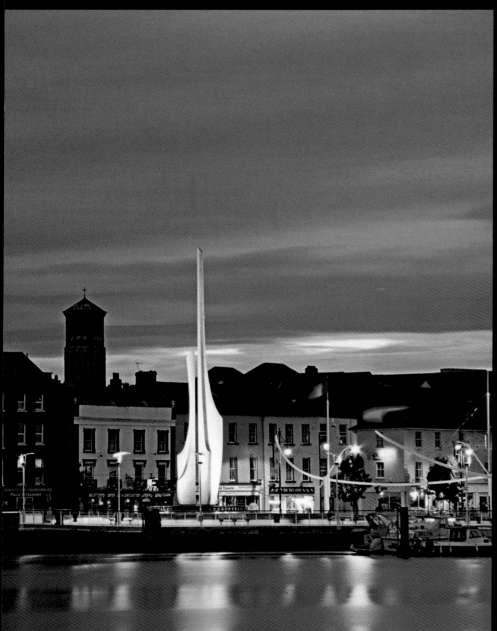

81 top left Waterford's town centre has been sensitively restored; it draws many visitors and provides the information they need.

81 top right Open squares, cobbled streets, colour-washed buildings, and attractive shops and restaurants, add to historic Waterford's charm.

81 right Reginald's Tower with its 20 ft/6 m thick walls dates to 1185. The statue commemorates Father Luke Wadding (1588-1657), missionary, scholar and teacher.

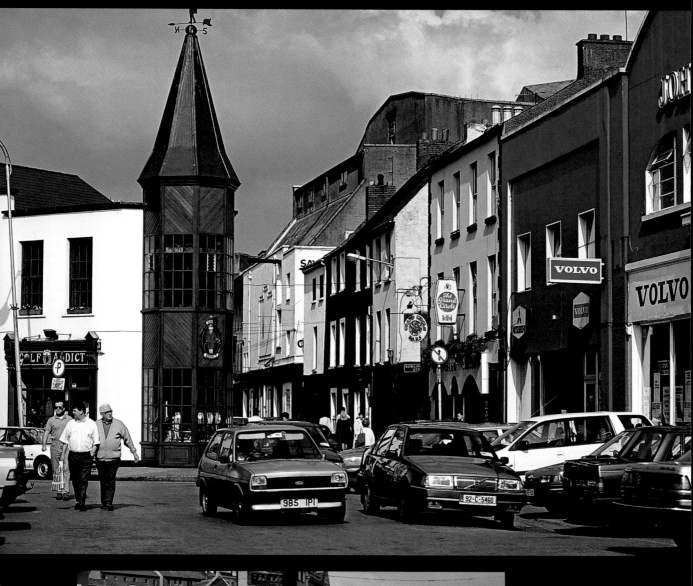

CORK
THE CITY
OF WATERWAYS

To the southwest lies Cork (in Irish Corcaigh, meaning marshy), founded by St Finbarr in the 6th century, now Ireland's third largest city. Thanks to its excellent harbour, renowned university and numerous cultural institutions and activities, Cork is a buoyant, bustling city that takes pride in its openness and such events as its exuberant and hugely popular Jazz Festival, held every October. Trisected by the River Lee's north and south channels, Cork has handsome quays, bridges and waterfront buildings. Two distinctive churches merit visits. St Finbarr's Cathedral, designed by the leading Gothic Revival architect William Burges, was built in the 1870s, with three spires, elaborate stone tracery and stained-glass windows. St Ann's Shandon, a landmark structure on high ground beyond the Lee's north channel, has classical lines and a soaring pepper-pot steeple. Its bells are famous. The once busy Butter Exchange is now the Shandon Craft Centre, selling crystal, tweed, and jewellery worked on the premises. The restored Cork City Gaol offers remarkable but grim reconstructions of prison conditions of the last two centuries. In an imaginative example of multi-use planning, the Gaol also houses the Radio Museum Experience. The Crawford Municipal Art Gallery, built in 1724 as the Customs House, and nearby Paul Street are rewarding; the former for its splendid collections and the latter for its stylish boutiques, bars and restaurants. Blarney Castle and its famous Stone are essential viewing.

Scarcely 20 miles/32 km southwest of Cork is Kinsale, known for its charming but compact town centre, now home to many fine restaurants. Yachting and an annual Gourmet Festival draw many visitors, while lovers of military fortifications explore the mighty bastions of the late 17th-century Charles Fort at Summer Cove.

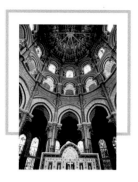

84 top The lofty, richly detailed apse of St Finbarr's Cathedral, looking toward the high altar.

84 centre top In the foreground the tower of St. Ann's Shandon.

84 centre bottom and bottom 19th-century sculptured heads and the pulpit (bottom) in the highly decorated interior of St Finbarr's Cathedral.

85 St Finbarr's Cathedral, named for Cork's patron saint, was built in the Gothic Revival style in the 1870s.

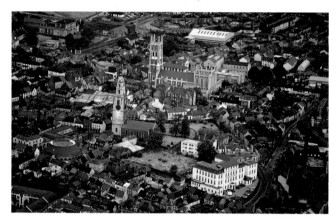

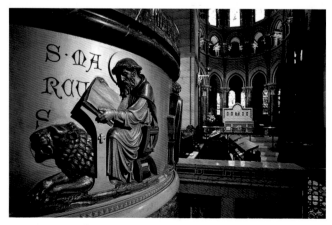

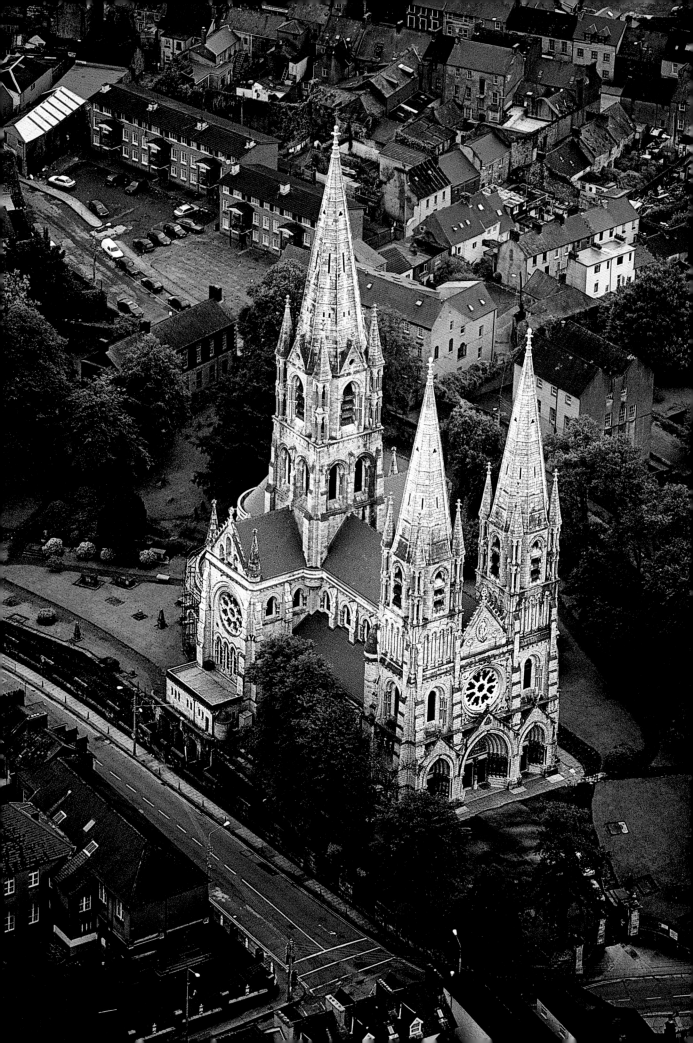

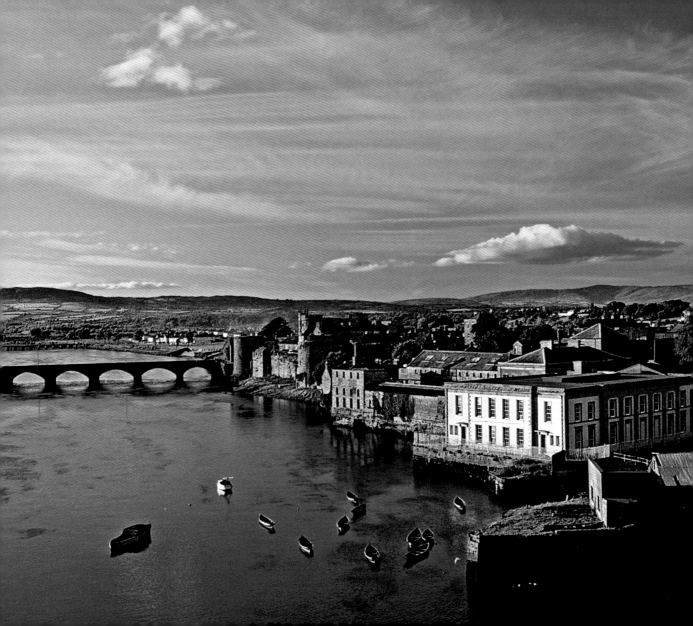

LIMERICK
BRIDGE AND CASTLE

Tripartite Limerick (it divides into King's Island, Englishtown and Irishtown) rewards the visitor who learns its troubled history. Founded by the Vikings far inland at the head of the Shannon estuary, it guards access to the rich farmlands in the nation's heartland.

They built extensive city walls; in 1210, King John of England added a great castle of round towers and curtain walls. Centuries

subsequent restorations have left the church with an ecumenical mixture of styles, but it retains a remarkable series of 16th-century misericords.

St John's Cathedral, in the Irishtown district, has a 280-ft/85-metre spire, Ireland's loftiest. Lovers of Irish Georgian architecture will admire St John's Square and the greater number of Georgian buildings in the Newtown Pery district. Not to be missed in the

later, devotedly Catholic Limerick suffered sieges and capture by the Protestant English, by Cromwellian armies in 1651 and by William of Orange's forces in 1691. The city's historic heart is King's Island, site of the castle and of St Mary's Cathedral. Though built in 1172 (a Romanesque door survives),

Old Customs House is the Hunt Collection, a remarkable assembly ranging from early Middle Eastern artifacts to Celtic treasures and modern paintings.

John Hunt was also responsible for the magnificent restoration and refurnishing of nearby medieval Bunratty Castle.

86-87 Thomond Bridge and King John's Castle (dating to 1200) frame the Shannon. The tower of St Mary's Cathedral is visible on the right.

87 top left Limerick's Merry Fiddler offers all the cheer and welcome expected of a traditional Irish pub.

87 top right Limerick is prepared to refresh the visitor, as this pair of establishments confirms.

87 bottom left King John's Castle is known for its great round towers and extensive curtain walls. For centuries it controlled entry to the Shannon.

87 bottom right This dignified façade suggests food, drink and conversation in comfortable and unhurried surroundings.

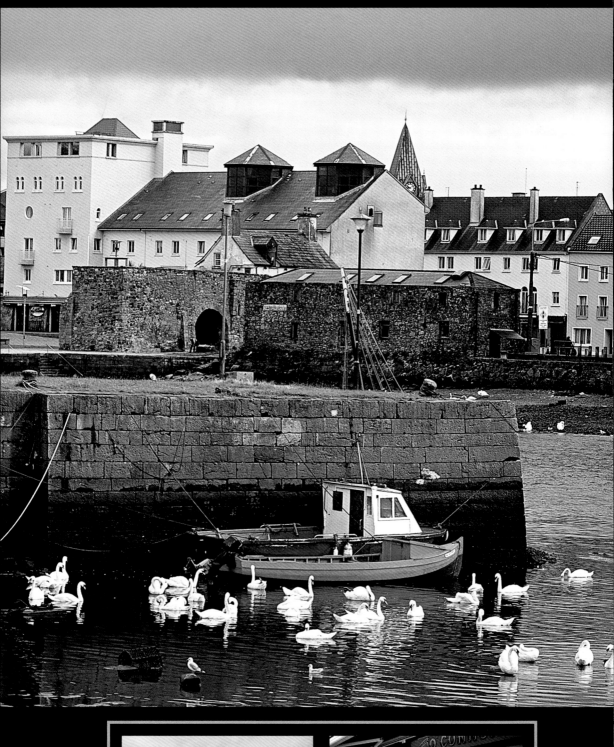

GALWAY
GATEWAY TO THE WEST

Once a prosperous port, Galway on the west coast, with its splendid bay and deeply rural hinterlands, suffered wholesale destruction in 1625 and 1690, a victim of Cromwell's and then William of Orange's onslaughts against Catholic Ireland. Today, with a renowned university, a sensitively restored historic town centre and a number of hi-tech industries, plus its popular July Arts Festival, the Races, and September Oyster Festival, the city on the River Corrib is thriving. Historic sights include the

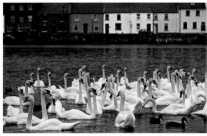

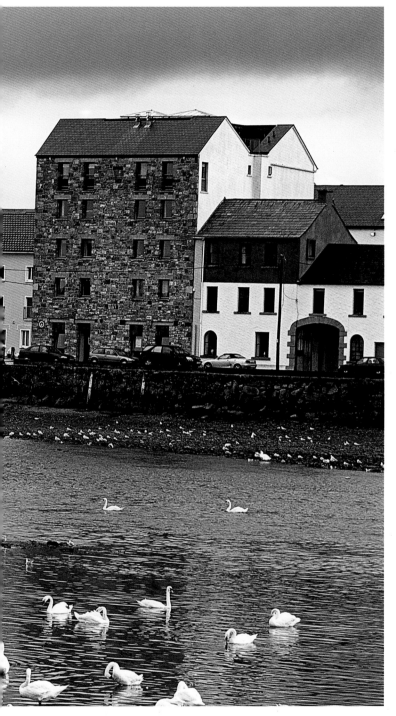

Spanish Arch, a fortified extension to the massive town walls and adjoining quays. Two churches are of interest: St Nicholas Collegiate Church, built in the 14th century, with its fine gargoyles and individual spire, and the Catholic Cathedral, whose somewhat heavy Romanesque walls and dome conceal a magnificent interior. Close by is University College, faux-Tudor in style and built in red brick. The Eyre Square area includes a fine small park, a number of narrow but trendy streets and a modern shopping centre.

88-89 and 89 bottom The Spanish Arch, on the left, marks the site of the old docks by the River Corrib, where swans swim free.

88 bottom left The copper-domed Cathedral of St Nicholas is modern; it was completed in 1965.

88 bottom right For many, a call at the local bakery is a standard morning event.

89 top Narrow, curving streets and small buildings are typical of Galway's older sections.

SLIGO AND DONEGAL THE YEATS COUNTRY

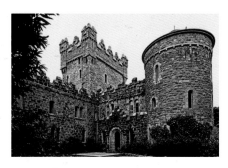

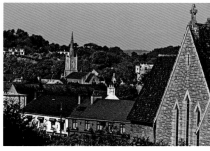

Northwards, and despite its strategic position on the Garavogue river and its 13th-century role as a FitzGerald stronghold, quiet Sligo retains little of its earlier architecture other than Sligo Abbey, where Gothic and renaissance carved stonework survives, together with a fine high altar. Near the town, however, is the great Carrowmore Megalithic Cemetery, which, though pillaged for building stone, still contains sixty or so intact passage graves. Sligo's appeal is the access it gives to beaches, and its association with William Butler Yeats who immortalised nearby Lough Gill's 'Lake Isle of Innisfree'. Donegal town seems to shelter in the lee of its castle. Built in 1610, it is now a partially restored ruin with interesting turrets, gables and windows; it houses a local historical collection. The town has a handsome market square (the Diamond); adjoining are the remains of Donegal Abbey, now a ruin save for an extant cloister. A mile/1.6 km or so away is the inviting Donegal Craft Village, where local craftspeople exhibit their wares.

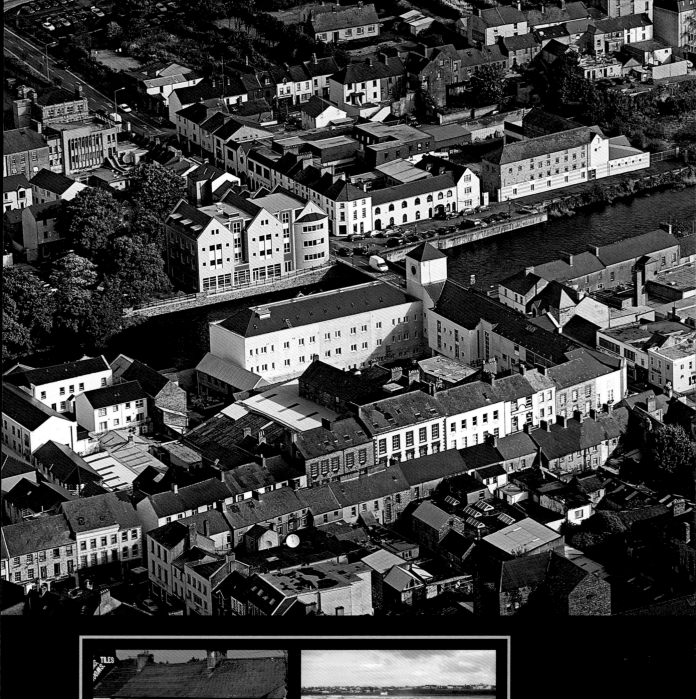

LONDONDERRY CITY WITHIN THE CITY

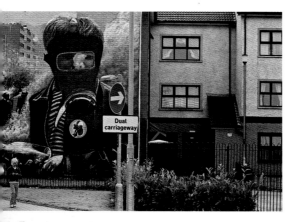

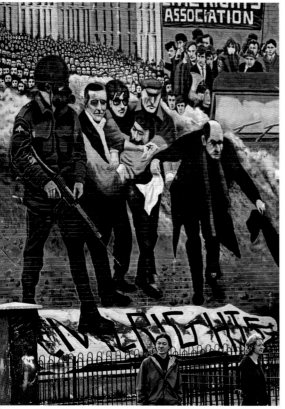

Ancient Derry, Ulster's second largest city, became Londonderry in 1613. After being taken over by the British, it was granted as a 'plantation' area to the London guilds.

A walk atop the fully intact encircling wall, some 20 feet/6 metres high, gives fine views of the well-preserved historic town centre. Within it is St Columb's Protestant Cathedral, built in 17th-century Gothic style; close by is Bishop's Gate.

At the midpoint of the walled city is the Diamond, a park-like square curiously containing a war memorial originally made for Sheffield in England.

Also within the walls is the Tower Museum, whose exhibits trace the city's history.

Outside rises the Guildhall, a Neo-Gothic building, with exhibits depicting the historic but unsuccessful siege that James II's Catholics laid against the city in 1689.

92 top Protestant-Catholic strife, exacerbated by aggressive murals, has ended only recently in Londonderry. Depicted here is a Catholic section.

92 bottom Another striking mural promoting the Catholic cause in Londonderry, where peace is recent and fragile.

92-93 A steeply climbing street of modern houses in historic Londonderry.

93 top left Below and beyond the bronze cupola, the War Memorial (originally designed for Sheffield, England) rises on its white plinth.

93 top right St Columb's Cathedral stands in Londonderry's historic walled centre. It was completed in the 1630s.

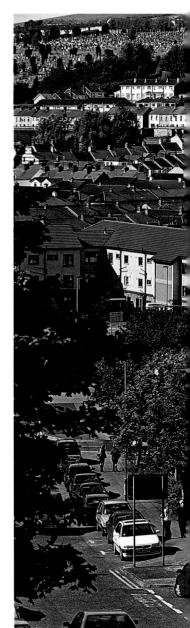

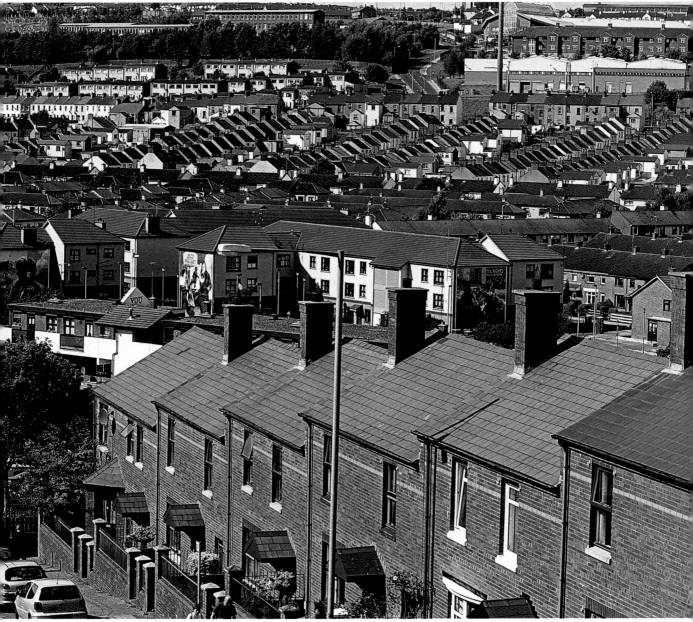

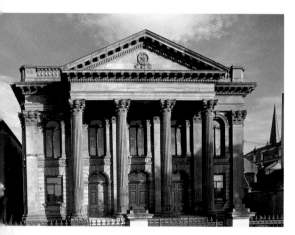

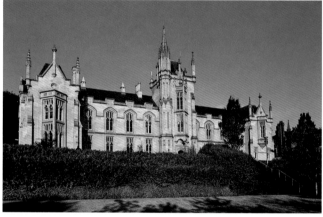

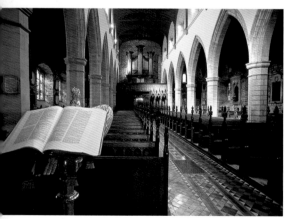

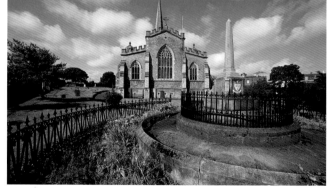

94 top The architecturally eclectic Guildhall houses a museum commemorating the Catholic siege of the Protestant city in 1688.

94 centre left Londonderry's impressive courthouse, designed in the Classic Revival style.

94 centre right Magee College was endowed by Martha Magee, the wife of a Presbyterian minister, and erected in 1865. It was intended as a training base for Presbyterian ministers.

94 bottom left The nave of St Columb's Cathedral. Major restoration of this 17th-century nave was undertaken in the 19th century.

94 bottom right St Columb's Cathedral is in a tree-lined close, seen from the west. To the right is a war memorial.

95 The War Memorial (built in 1927) stands in an elegant square called the Diamond. The cupola tops a building adjoining it.

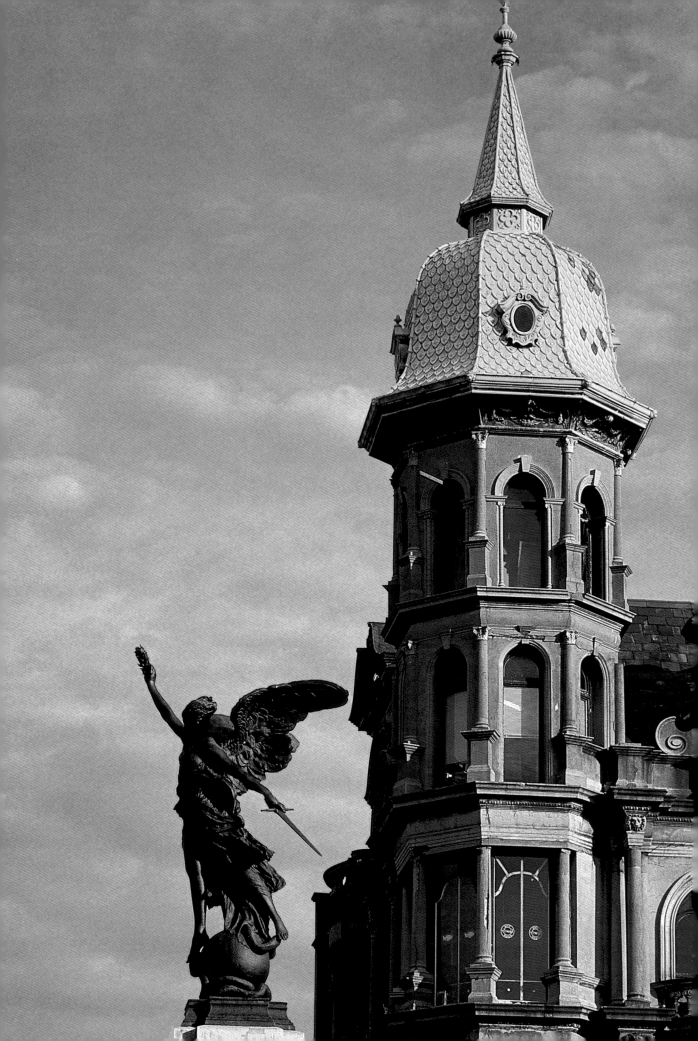

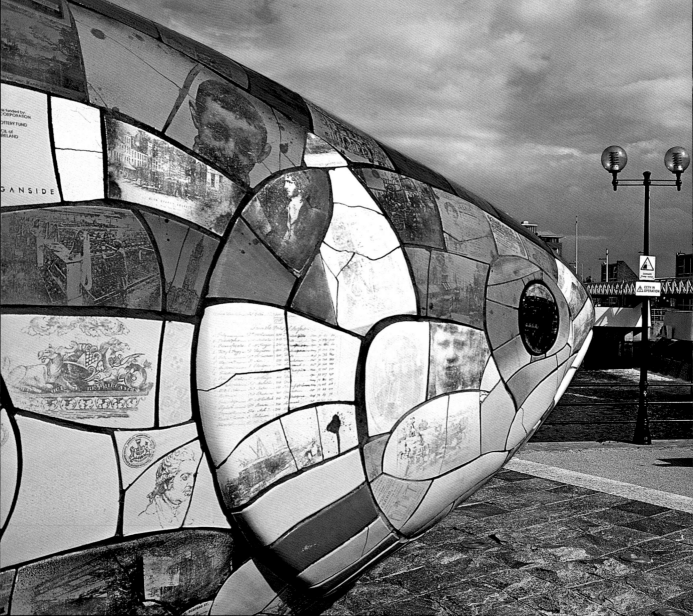

BELFAST
A PHOENIX CITY

Below the shoulder of County Antrim, the broad Belfast Lough cuts in, with Ulster's capital, Belfast, at its head. A proud, troubled city working to regain its turn-of-the-century prosperity, and scarred by decades of fierce Protestant-Catholic strife, Belfast is now largely peaceful.

Handsome Donegall Square, at the city's centre, opens onto the imposing mass of the lawn-flanked City Hall, which, with its corner

Romanesque and known for its brilliantly colourful modern mosaics. The soaring Albert Memorial Clock Tower on Queen's Square reflects Victorian Gothic taste; below it, close to the River Lagan, is the impressive Custom House in Florentine-palazzo style. The Lagan Weir redevelopment plan is remaking a significant stretch of the river by maintaining a water level high enough for recreational use of the river. The ultra-modern Waterfront

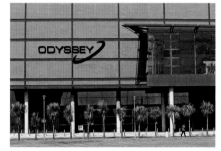

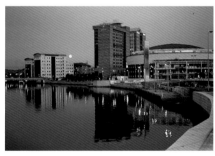

towers and central dome, recalls an ambitious late Roman basilica – despite being built in 1906. On Great Victoria Street stands the Grand Opera House, unashamedly Victorian in its red and gilt splendour. Beyond Donegall Place at the farther end of Royal Avenue stands St Anne's, the Protestant cathedral; of the same era as City Hall, it is

Concert Hall is already a major draw. The immense yellow gantry cranes that are visible mark the Harland & Wolff shipyard, part of the city's historic past and a force in its economic future.

An older more picturesque Belfast can be found between High Street and Ann Street, where narrow alleys called 'entries'

96 top This amusing modern sculpture sits across from Belfast's new Waterfront Hall, centrepiece of the Lagan River redevelopment project.

96-97 Every scale of the Big Fish sculpture tells a different episode of the story of Belfast.

97 top left The Waterfront Hall seats 2,250 persons in its main state-of-the art auditorium and 500 in a second one.

97 top right The new multi-function Odyssey Centre on Queen's Quay is promoting the revival of a once run-down waterfront area.

97 bottom left The Waterfront takes pride of place on the recently redeveloped Lagan River frontage.

97 bottom right Belfast's new office buildings, part of the city's extensive redevelopment programme, reflect strong faith in the future.

run between the two. The entries are known for their pubs, most with traditional furnishings. White's tavern claims to be Belfast's oldest; another, in 1791, was the first meeting place of Wolfe Tone's Revolutionary Society of Irishmen.

Belfast does not lack for parks. The attractive Botanic Gardens, close to the Lagan at Stranmillis Embankment, features a lofty Palm House of slender cast-iron ribs and glass as well as the Fernery – a sunken glade in whose shelter semi-tropical ferns, shrubs and plants flourish – and numerous walks through attractive plantings. Almost adjoining the Gardens stands Queen's University,

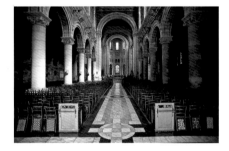

its main block built in brick in Tudor style, with a quiet inner quadrangle. The Ulster Museum and Art Gallery is located in the Gardens; its exhibitions range through Ulster's early history to its 19th-century industrial peak in shipbuilding, manufacturing and linen-weaving.

The Art Gallery is strong in Irish artists, and features both Jack B. Yeats (the poet's father) and the fashionable Belfast-born portrait painter Sir John Lavery. Those seeking sectarian political art can make their way to the Protestant enclave of the Shankill Road and the Catholic enclave of the Falls Road to see defiant and exhortatory slogans in blazing colour.

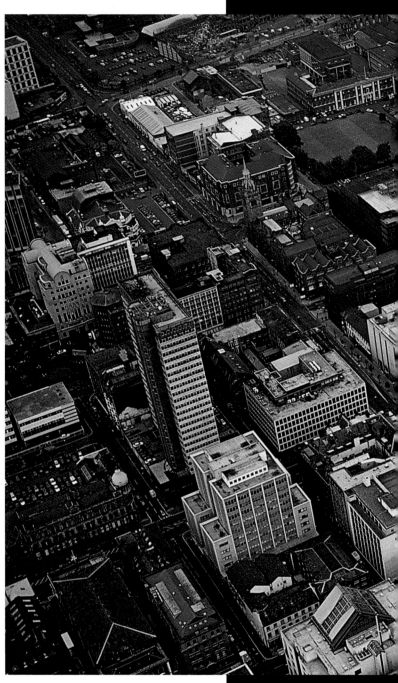

98 left The nave of St Anne's Cathedral. The Neo-Romanesque Protestant church is now one hundred years old.

98-99 Though occupying most of Donegall Square, City Hall manages to offer small parks for public use.

99 top left The Albert Memorial Clock Tower in central Belfast has a slight lean – but it's a long way from rivalling the Leaning Tower of Pisa.

99 top right The foreshortening of a street in Belfast shows a tight association between civil and religious life.

99 right Belfast's City Hall, built in 1906, occupies the centre of Donegall Square. Its copper-clad dome rises 173 ft/53 m.

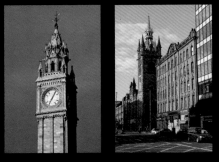

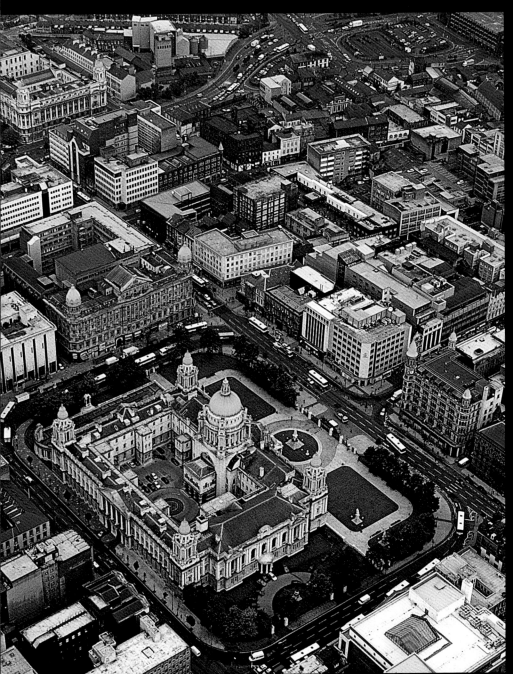

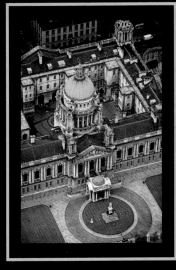

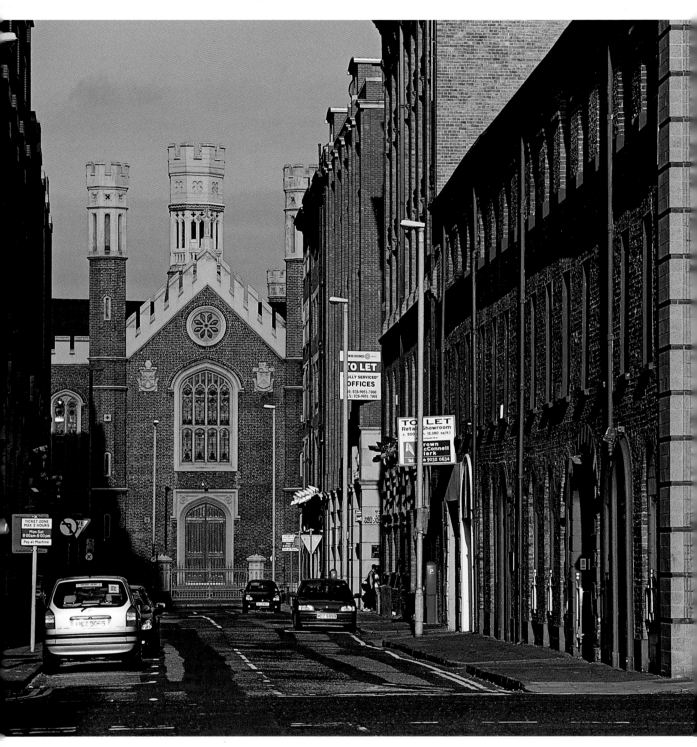

100-101 A mock-medieval building teases the eye at the end of a Belfast Street.

101 top Tricks of light and shade manage to leave a key word fully visible: enter for light and laughter . . .

101 centre top Belfast's fine Botanical Gardens (foreground) and Queen's University share a vast grassy campus.

101 centre bottom The Albert Memorial Clock Tower is visible from many points in Belfast. The red letter box (right) is a reminder of British rule.

101 bottom Belfast features an eclectic mix of traditional and modern architecture.

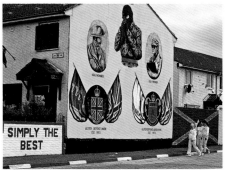

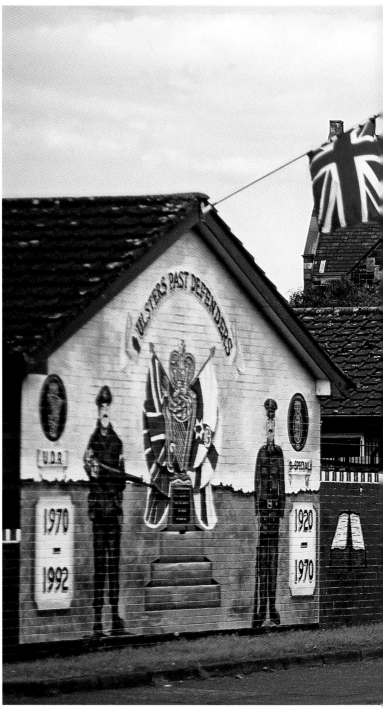

102 top Powerful but cryptic, the message of this mural
will not be lost on any resident of Belfast.

102 centre The masked gunman on this Protestant
mural with Union Jack is a reminder of past violence.

102 bottom This highly imaginative and brilliantly
colourful mural holds out the hope of peace and unity.

*102-103 Murals in Protestant West Belfast make no
secret of where loyalties lie.*

*103 bottom These military-insignia style 'badges'
emphasise neighbourhood loyalty to the United Kingdom.*

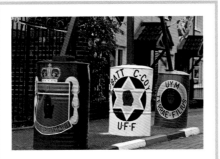

ARMAGH AND ATHLONE TWO INLAND TOWNS

What of the towns of Ireland's interior? An almost random quartet of these pleasant small towns reveals their variety and interest. Armagh, Ireland's ecclesiastical capital, located in the Ulster county of the same name, is associated with both St Patrick and the High King Brian Boru. St Patrick founded a church here in 455, but the site is now occupied by St Patrick's Cathedral, a largely 19th-century Protestant church in whose grounds Brian Boru's bones are claimed to all result in part from generous public benefactors. St Patrick's Trian ('third') is a fine heritage centre that presents Armagh's history. Athlone, almost at Ireland's centre and guarding a ford on the River Shannon, was once a strategic stronghold through which the English hoped to control unruly Connacht and it was later a Jacobite hold-out after the battle of the Boyne. No longer does the castle dominate the town; instead, rising over its remains is the twin-towered church

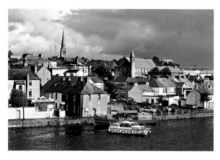

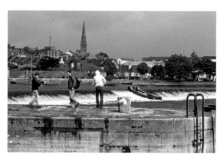

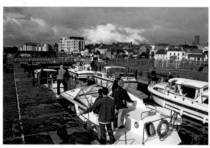

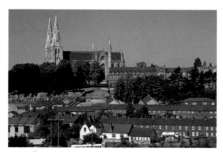

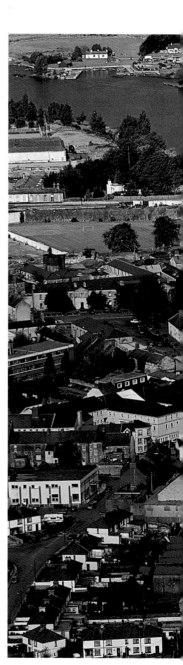

rest. The Catholic cathedral dedicated to St Patrick is an imposing twin-spired Gothic style building, entirely mid-19th century. Both churches are built on high ground, each displaying a formidable profile. The town itself is rich in Georgian buildings: the Public Library, the broad Mall with its flanking Georgian houses, and the County Museum of Saints Peter and Paul, formidably severe for its construction date of 1937. Today this pleasant small town has some clothing manufacturing and boat-building; it has also quietly reinvented itself as an efficient centre for visits to Lough Ree to the north and Clonmacnoise to the south, as well as for its own attractive local area.

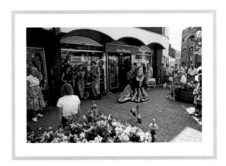

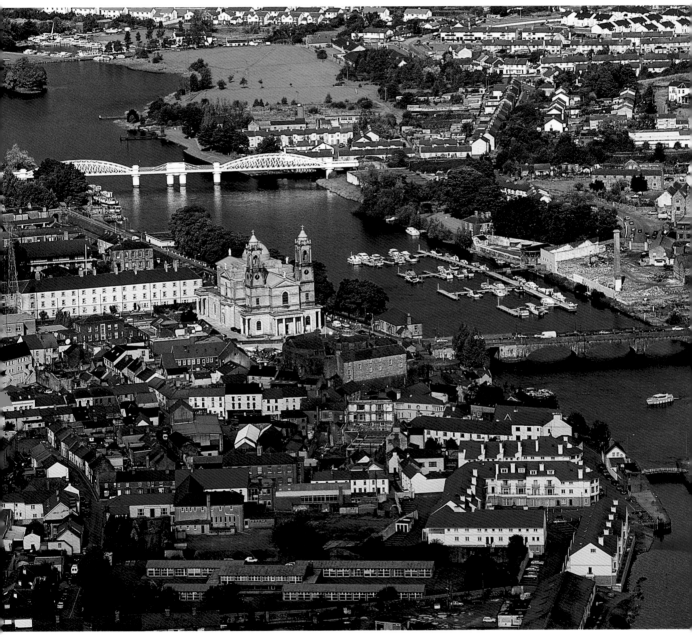

104 top left River views and waterside walks come with many homes in Athlone.

104 top right An uncrowded weir on the River Shannon in Athlone provides an ideal meeting place.

104 bottom left Boats catering to visitors depart from Athlone; north to Lough Ree and south to Clonmacnoise.

104 bottom right St Patrick's Cathedral, seat of Ireland's Catholic primate, stands on a ridge above Armagh.

104-105 The great 19th-century church of Saints Peter and Paul dominates Athlone; below it stands Athlone Castle, flanking the River Shannon.

105 top A trio of musicians and a young dancer entertain passers-by on this busy Armagh street.

106 top left St Mary's is the Catholic cathedral of Kilkenny. Designed by William Deane Butler and built in the 19th century, the cathedral draws its inspiration from Norman architecture.

106 top right Two gentleman of leisure chat in a small park beneath an ancient wall. It is likely that a pint or two will follow . . .

106-107 Flowers abound on this charming Kilkenny street – and of course, a handy pub offers refreshment to tired shoppers . . .

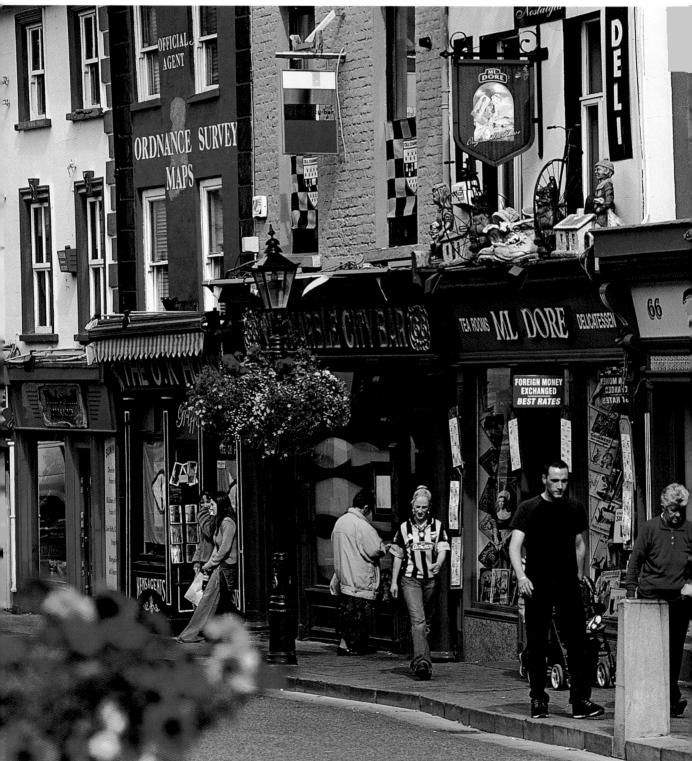

KILKENNY
AND CLONMEL
THE HIDDEN GEMS

Kilkenny, an ecclesiastical city in the body of a town, once visited will not be forgotten. It was important in medieval times as an Anglo-Norman capital of Ireland, and the famous Statutes of Kilkenny of 1366 were designed to prevent intermarriage, trade and integration between the overlords and their Gaelic subjects. Kilkenny Castle, dating back to Strongbow, but frequently altered, restored and now in part 'Victorianised', has a magnificent long gallery with a fine hammerbeam roof.

The castle, beautifully situated between the River Nore and The Parade, gives onto a magnificent park. The High Street, with the Tholsel (the still used 18th-century City Hall) and St Kieran's Street, with the famed Kyteler's Inn (once the home of a witch named Alice Kyteler), offer an unrivalled array of colour-washed Georgian buildings. St Canice's Cathedral, despite vandalisation by Cromwellian armies, retains a fair amount of its original Romanesque and later Gothic stonework and decoration. Rothe House, a rich merchant's dwelling, retains most of its original Tudor features and is now a small museum.

A fleeting visit to Clonmel, County Tipperary, rounds off this quartet of inland towns. This busy town on the River Suir has diversified and is an administrative centre for the surrounding area. Though Clonmel has a restored Tudor town gate, some remnants of its ancient walls, and an attractive parish church, it is perhaps more interesting for its literary associations than its architecture. The exuberant, experimental novelist Laurence Sterne (Tristram Shandy, 1767–70: A Sentimental Journey, 1768) was born in Clonmel. George Borrow, the chronicler of picaresque life, learned Irish during a brief attendance at the local school; and the novelist Anthony Trollope spent two of his early years in the town as a postal inspector. Dog fanciers will be pleased to know the town breeds and exports greyhounds.

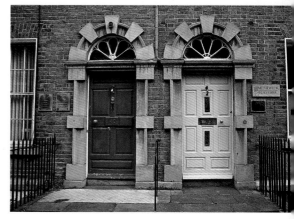

107 top The old campus of Kilkenny College, a Church of Ireland co-educational boarding and day school.

107 centre Kilkenny Castle, looking west across the courtyard. Begun as a Norman fortress, this much-expanded castle has a magnificent Long Gallery.

107 bottom Whether home or office, a building deserves an inviting front door.

108 top A town of attractive streets and monuments, good shops and fine restaurants, Clonmel draws the curiosity of many visitors.

108-109 It's hard to imagine being more than a short distance from a pub and a pint in any Irish town like Kilkenny.

109 top All needs met in one place

109 centre There's nothing overly discreet in Irish shop signs; like this one in Kilkenny, they are large and clear.

109 bottom The size and prominence of this establishment in Kilkenny confirms the importance of the pub in Irish life.

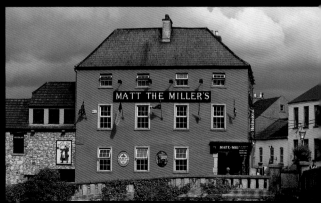

110 top left In this modern statue on Croagh Patrick, the saint looks out over Clew Bay.

110 top right Faith sustains the weary in their long climb to attend mass and pray at the peak of Croagh Patrick.

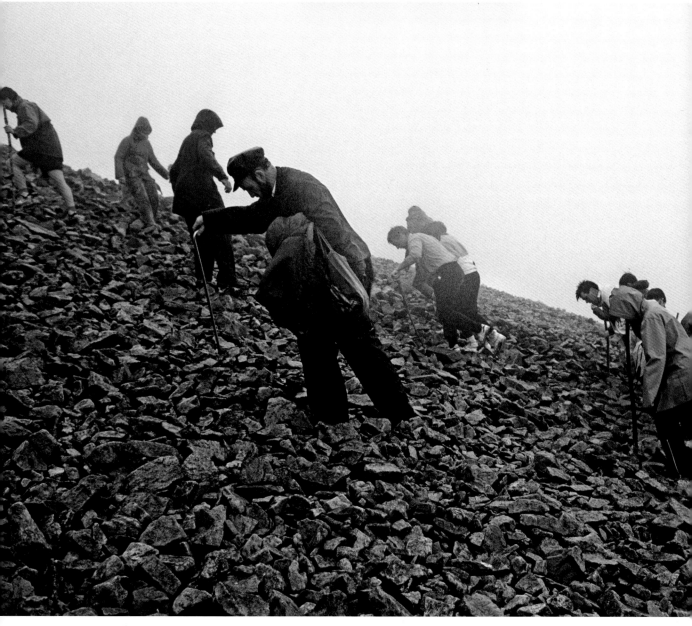

110-111 On the last Sunday in July, pilgrims flock to Croagh Patrick's 2,500-ft/762-m summit. In 441, St Patrick fasted there for 40 days.

111 top Pilgrims carry a statue of the Virgin Mary up Croagh Patrick. Here, tradition has it, the saint rid Ireland of snakes.

111 bottom In honour of St Patrick, thousands of pilgrims make the challenging ascent of Croagh Patrick, Co. Mayo, many of them barefooted.

THE IRISH CULTURE AND CUSTOMS

How can anyone possibly 'define' the Irish people, or describe their culture and folklore? Once pure Celtic, but over centuries diluted by Vikings, Anglo-Normans, Scots and English, most Irish today draw upon a complex heritage. Celtic Ireland is recalled in terms of saints, kings and strong women. Chief among them are Cúchulainn, a warrior who defeated Queen Maeve of Connacht's plot to capture a prize bull, the pride of Ulster, but who was later lured to his death. (Maeve's great tomb is a showpiece of Carrowmore megalithic site.) Fighting Fionn Mac Cumhaill, a champion in the defence of Ireland, is remembered as the giant who built the Giant's Causeway in County Antrim to bridge the sea to the Scottish island of Staffa, where his heart's love lived. Truly heart-rending is the legend of the Children of Lir, the king whose second wife,

jealous of his four children, took them to a lake and by casting a spell upon them turned them into swans for nine hundred years. Stricken with remorse, she endowed them with the art of song . . . With the Viking invasions and Irish resistance, historical figures increasingly enter the record, and tales of heroic kings and clan chiefs – all too often fighting each other – were recorded. The famed Ulster Cycle, the Book of Armagh and the Book of Leinster are among several surviving chronicles. Despite the Anglo-Norman invasion of 1169 and subsequent pillage, scholarship and literature did not entirely perish; as late as 1632 Franciscan monks compiled the historical work The An-

nals of the Four Masters. Nonetheless, with the old Gaelic aristocracy increasingly dispossessed or impoverished, Gaelic literature declined, though it was not lost to oral tradition. Saints and miracle-workers loom large in Celtic and early Christian Ireland. Legend recounts that St Patrick rid Ireland of snakes (though it is unlikely Ireland ever had any); St Brendan, tradition has it, sailed to America in a coracle (though there is no record of his arrival). What is almost beyond belief until seen are the great treasures of Christian Ireland of the 5th to the 10th centuries, among them the Book of Kells and the Book of Durrow with their exquisite pictorial capitals, wonderful curvilinear designs and elegant lettering. Other priceless illuminated manuscripts and chronicles present vignettes of the tools, clothing and life of the times. Even in today's secular environment, Irish religious life is surprisingly vigorous; church attendance is high, religious processions are numerous. The ancient pilgrimage site of Croagh Patrick and the modern St Patrick's Day parade have a modern rival in Knock Shrine, County Mayo, which came into being in 1879 following the apparition of the Virgin Mary. Today, with its own international airport and huge new basilica, Knock Shrine draws over 500,000 visitors annually; both Pope John Paul II and Mother Teresa have visited it. Throughout the country fraternities and sororities flourish and it is common to see the annual celebrations of saints' days and shrines – the priest and parishioners in procession, flowers and music much in evidence.

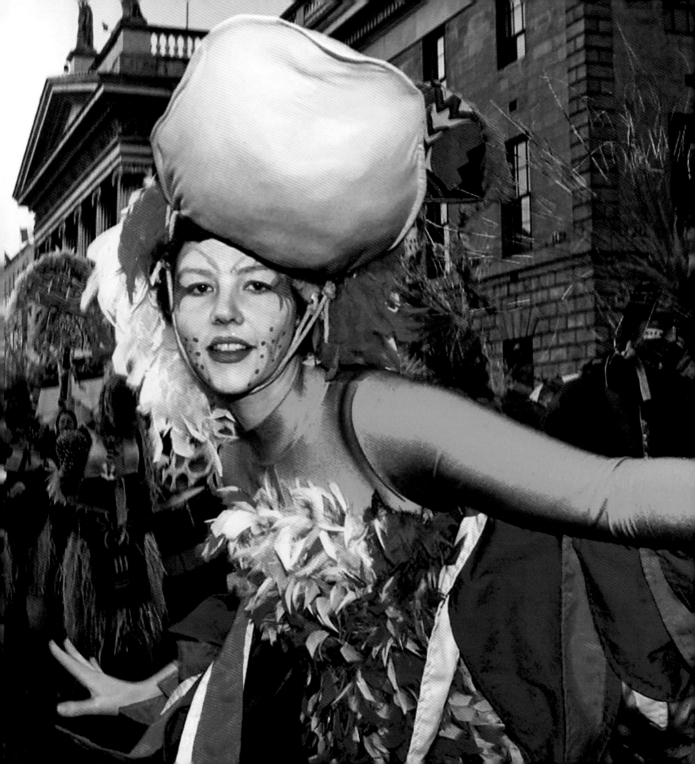

112-113 *St Patrick's Day is celebrated throughout Ireland, as much for good times as for religion.*

113 top left *Both 'the wearing o' the green' and imaginative personal displays of Ireland's national colours add to the highlights of St Patrick's Day.*

113 top right *Every last inch of this young boy's face reflects patriotic fervour as he enjoys St Patrick's Day.*

113 centre and bottom *For many, St Patrick's Day celebrates festivity rather than faith. In Dublin half a million people celebrate in the streets.*

Despite a troubled history, Irish reminiscence and talk take other, happier forms. At the raising of a glass, be it of Guinness, a local ale or beer, or a fine whiskey, we Irish will conjure up our rich folkloric past, tell stories, make music, and sing songs – have a bit of 'craic' ('crack'), as we say. Tales of long ago, of heroes and fair maidens, whether transcribed from oral tradition or born on paper, fuel the Irish imagination and are frequently but always engagingly retold. If ale is

ness: Old Bushmills Distillery in County Antrim has been distilling a single malt since at least 1609, and other distinguished distilleries offer renowned single malts or blended whiskies. At best, whiskey is sipped and savoured with growing appreciation while the conversation flows or the informal music-makers strike up a tune.

Drink of course leads to food, and the Irish have hearty appetites. Locally harvested fresh, briny oysters, mussels and prawns

the preference of the hour, the choice may well be Guinness, first brewed in 1759 in Dublin and now drunk in one hundred and twenty countries worldwide. The advertising slogan 'Guinness is good for you' has pulling power; moreover, the drinker knows that Guinness is more than a drink – it's a food! Other ales have strong followings, and every preference can be met.

Bars or public houses – pubs – range from a cosy room in the small village house to veritable Victorian palaces, often boasting marble or tile, mahogany furnishings, fine mirrors, and elegant brass and ceramic beer-pumps.

The drinking of whiskey is no casual busi-

are justly famous, as is Irish salmon; and 'champ,' potatoes mashed in milk with spring (green) onions added, is a fine accompaniment. No one should miss a traditional breakfast of Irish bacon (rashers), black and white puddings and eggs, or a traditional dinner of baked or boiled ham (bacon) and cabbage followed by apple pie slathered in thick cream.

Bread and potatoes are humble offerings in many cuisines, but in Ireland freshly-baked soda bread and boiled new potatoes can be a true delight. Locally grown and fresh are the hallmarks of Irish cuisine, and in rural parts the food may well be from the household's own garden.

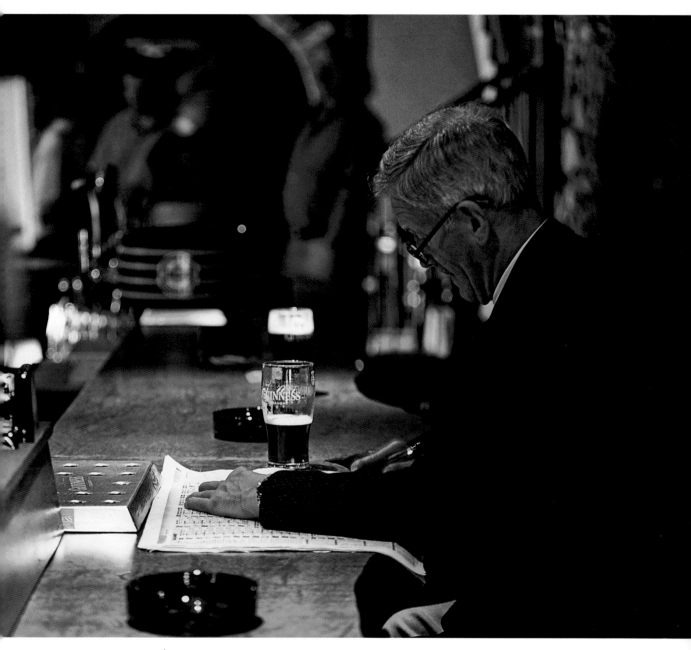

114 top This pub scene in Westport, Co. Mayo, confirms that though Guinness is a national favourite, Ireland welcomes imported beers.

114 centre left Even in remote Co. Mayo, the steel keg has replaced the traditional wooden barrel, though without denting beer sales.

114 centre right Top hats, a church and a wedding provide a suitable occasion for a needed but dignified drink.

114 bottom left Bantry, Co. Cork, may be off the beaten track, but its residents' tastes in alcoholic refreshments are truly international.

114 bottom right This 'traditional Irish pub' in Cahir, Co. Tipperary, adds a cheerful patriotic display to its invitational message.

114-115 A pub, a pint and a contented man. A typical Irish pub scene captured in Listowel, Co. Kerry.

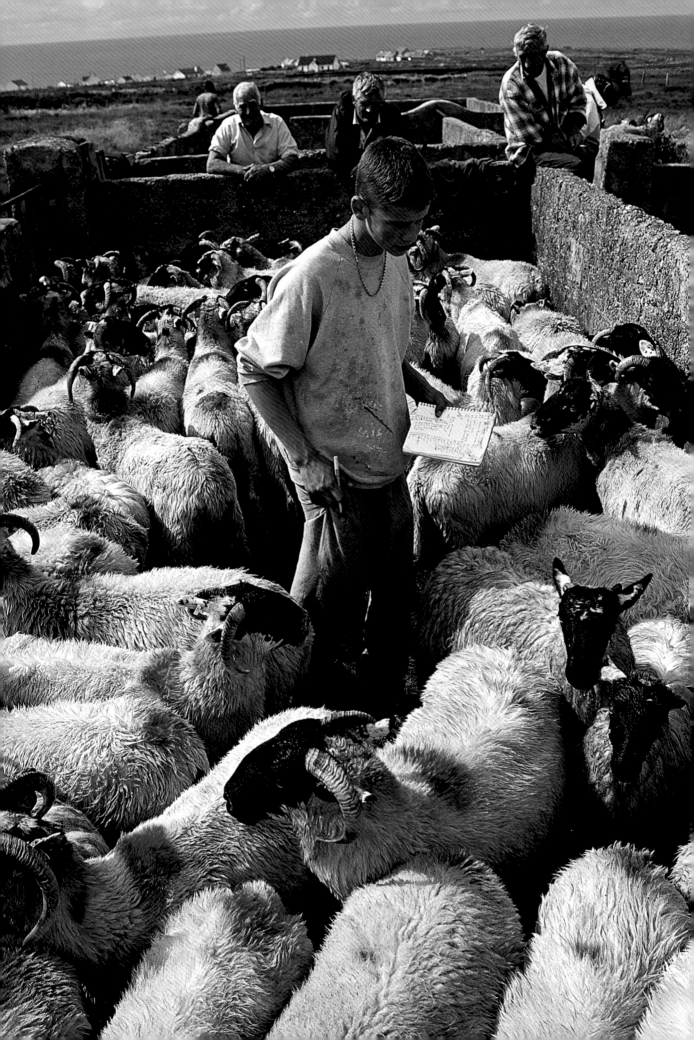

Active visitors will meet native Irish who are still strongly connected to 'traditional' Ireland, particularly in the west. In Munster and Connacht especially, it is still common to see farmers driving cattle down country lanes, bounded by small fields enclosed by dry-stone walls, and to see turf-cutters with their tractor-drawn carts – often of pleasingly vintage profile – at work in the areas of ancient bog and marsh, cutting turf sods into neat blocks for drying, later to burn with gentle heat and a pleasant fragrance. In the coastal villages, two or three men setting out in a small fishing boat continue an age-old tradition of bringing the sea's often hard-won bounty to both the local market and the family table. The boat may have traditional lines, but its diesel engine and navigation aids are entirely modern.

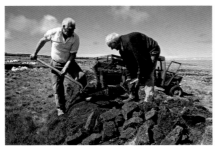

Though many have lived from land or sea, the Irish have also been known throughout history as craftspeople: weavers, gold- and silversmiths, potters and woodworkers. In the past, they needed to be: their 'visitors' were more likely to be invaders than merchants. Today an increasing number of young Irish men and women are taking up crafts, making and selling what they have woven, crafted, carved or painted, and are selling their products, individually or in craft co-ops, sometimes set up in converted warehouses or factories. Patterns and design combine tradition with excellence, and finishing standards are high.

Ireland is best known for wool, for tweed (among which Donegal tweed is renowned for quality) and for linen, but today the nation is also proud of designers such as Louise Kennedy, John Rocha, Mariad Whisker, Paul Costello and others whose names are making fashion news as Ireland participates in the European Union marketplace.

116 Though Ireland's flocks seem to wander at will, their owners keep careful tallies, as here at Bloody Foreland, Co. Donegal.

117 top A farmer with a milk churn. Irish women don't shirk hard work, and the heavy sweater suggests outdoor labours.

117 centre A farmer on Loughros Point, Co. Donegal, examines a bullock. Sick livestock can mean heavy financial loss.

117 bottom Cutting turf in Co. Donegal. Hand cutting persists though tractor and trailer have largely replaced donkey and panniers.

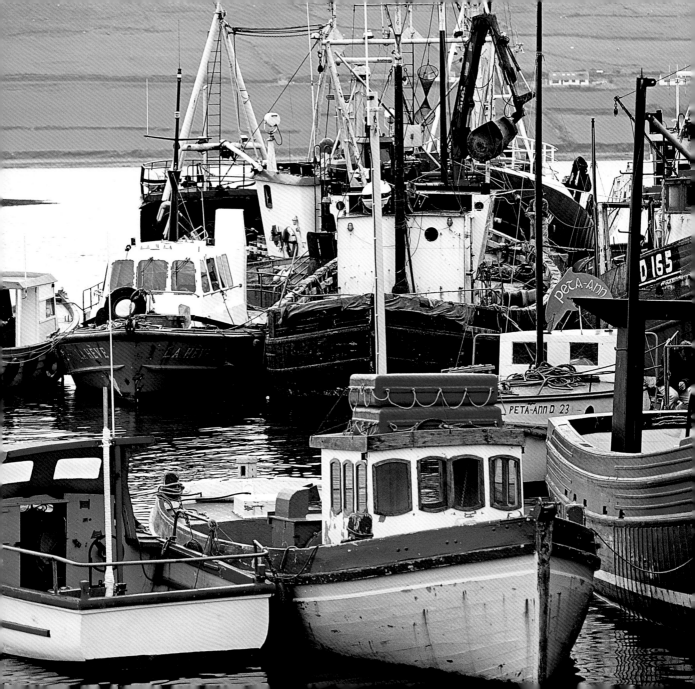

118-119 Brightly painted boats in Dingle harbour,
Co. Kerry. Fishing boats and holiday craft together
make Dingle Bay ever busy.

119 top Hauling in the net; overfished seas mean
smaller catches. The photograph was taken at
Ballycastle, Co. Antrim.

119 centre 'Girl Maureen' of Bunbeg, Co. Donegal.
Girls, boats and ocean waters share one behavioural
characteristic: unpredictability.

119 bottom Fishing boats at anchor in Tralee,
Co. Kerry. Fishing has become increasingly regulated,
cost-burdened and difficult.

120 top The Irish fiddler, the guest at every gathering, is usually a skilled musician, with a repertoire extending far beyond traditional tunes.

120 centre top This pub in Rossbrin, Co. Cork, promotes a local beer and is prepared to offer musical entertainment with it.

120 centre bottom When it comes to music, the Electric Bar in Londonderry seems prepared to pass on electric guitars and amplification . . .

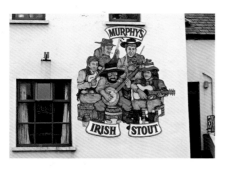

120 bottom Here in Cork, a splendidly uniformed pipe and drum band plays in a stadium before the football match commences

120-121 Dublin pubs do more than serve drinks: memento-laden walls, music and talk are all part of the typical offerings.

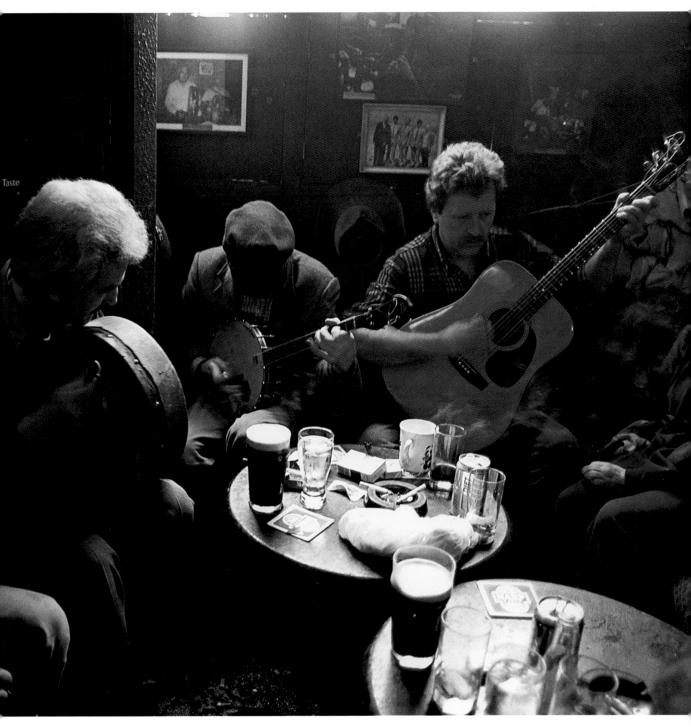

Taste

Ireland has an ancient and rich musical heritage. Say the words harp or jig – and Ireland immediately springs to mind. Some very old religious chants survive in liturgical documents, but much of the traditional music so valued today is part of Gaelic oral inheritance, recounting deeds, love songs and laments once sung in halls of chiefs and great men.

The record gets richer from the 1600s on, with folksongs often reflective of loss, hope and the sufferings of Ireland, as the plantation system and the harrying of the native Irish took hold. This tradition was fed by the tragic events of the next three and half centuries. Irish imagination and enthusiasm constantly enriched the tradition, so that today in addition to formal musical events, Irish social life is enriched by informal ensemble playing with whatever instruments are at hand, often a 'fiddle' (violin), flute, melodeon and bodhrán, the traditional Irish handheld drum of goatskin stretched over a frame, played with a single stick. These gatherings, often with dancing – céilí – are now a staple of Irish social life.

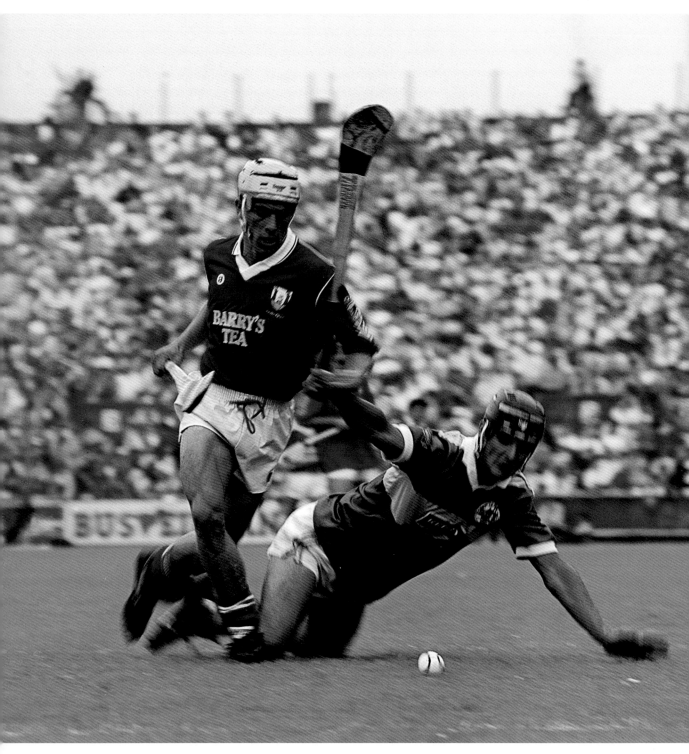

122-123 A hurling match in progress in a Cork stadium. This superfast game, unique to Ireland, is a closely followed sport.

123 top This colourful advertisement in Cashel, Co. Tipperary, shows both the hurleys and the helmets that players use.

123 centre left In this hurling match scene, the ball is high overhead. Moving fast at body level, it can cause injuries.

123 centre right A Gaelic football match in progress. In Gaelic football, the ball can be carried during the course of play.

123 bottom left Irish schoolboys playing Gaelic football in The Curragh, Co. Kildare. The coppery-toned hair some boys display is common in Ireland.

123 bottom right A construction firm and an auto brand cheerfully advertise each other in the city of Kilkenny.

Despite a popular myth that places the Irish in the pub or around the table, we Irish are aficionados of sports of every kind. In fact the country is a sportsman's paradise. Many frequent the racetrack not just in the hope of a successful wager but because they are acutely interest in the pedigreed mounts, jockeys and the whole romance of

um. In addition to football (soccer), the Irish turn out in force for Gaelic football in which the ball can be carried. The Irish are proud of another 'Gaelic' sport, hurling, in which a wooden hurley and a ball move with dangerous speed.

Golf and fishing are immensely popular too. Most other sports, including sailing and

the track. The Irish Grand National and Derby are major events, with millions wagered; around the country, steeplechasing and flat-racing always draw crowds. The Dublin Horse Show puts showjumping centre stage. Little wonder that hunting and riding feature large in Irish literature.

The Irish field a formidable rugby team, with excitement building for various matches played at Dublin's Lansdowne Road stadi-

motor racing, draw enthusiasts, but generally take second place to the sports described above.

After a half-century of rapid change, Ireland today is a modern EU state, one with a remarkably rich heritage to which no brief sketch can do justice.

We hope that your visit to Ireland will kindle a life-long enthusiasm for our people and culture.

124 top Show jumping is the centrepiece of the Dublin Horse Show. The Aga Khan Cup is highly coveted.

124 centre left Prior to the 1,000 Guineas race at The Curragh, Co. Kildare, enthusiasts thoughtfully discuss which horse deserves their bet.

124 centre right Never let it be said that horse racing has to do only with horses: fashion is also on view at the track.

124 bottom left Betting, seen here at the 1,000 Guineas at The Curragh, Co. Kildare, is a serious business.

124 bottom right The Curragh course is proud of its role as venue for many of Ireland's premier and most fashionable racing events.

124-125 The 1,000 Guineas is underway and the thoroughbreds carry the hopes, fear and rent money of many thousands of big and small betters.

INDEX

PHOTO CREDITS

128 The Irish gypsy caravan is now a big draw for visitors. This colourful one is from Tralee, in Co. Kerry.

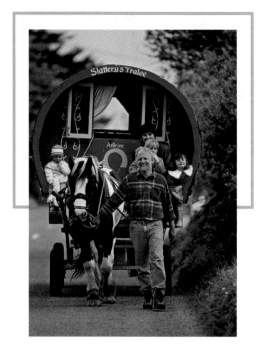

The author was assisted by the following people and institutions:

Scott E Hayes
Administrator St Patrick's Cathedral Dublin

Michael Cooper
Derry Visitor and Convention Bureau

Dearbhala Ledwidge
Heritage Officer Kilkenny County Council

Irish Consulate in Rome